THE VELVET PRISON

Artists Under State Socialism

MIKLÓS HARASZTI

Foreword by George Konrád

TRANSLATED FROM THE HUNGARIAN
BY KATALIN AND STEPHEN LANDESMANN
WITH THE HELP OF STEVE WASSERMAN

The Noonday Press
Farrar, Straus and Giroux
New York

To Vera Pécsi

English translation © 1987 by Basic Books, Inc.
First published in the West in French as *L'Artiste d'Etat*
© 1983 by Librairie Arthème Fayard
Unofficially published in Hungary in 1986 as *A Cenzúra Esztétikája*
All rights reserved
Published in Canada by Collins Publishers, Toronto
Printed in the United States of America
Noonday Press edition, 1989
Published by arrangement with Basic Books, Inc., Publishers

Library of Congress Cataloging-in-Publication Data
Haraszti, Miklós, 1945–
The velvet prison.
First published under title: L'artiste d'Etat.
1. Socialism and the arts—Europe, Eastern.
2. Socialism and the arts—Hungary. 3. Art—Europe,
Eastern—Censorship. 4. Art—Hungary—Censorship. I. Title.
HX521.H28813 1987 306'.47'0947 87-47509

CONTENTS

FOREWORD

By George Konrád

MIKLÓS HARASZTI is a dissident who mocks himself. He mocks himself because he is a born dissident. He was born in Jerusalem in 1945, but his parents preferred communism to Zionism, so they returned to Hungary to build socialism as minor functionaries. A slim, boyish man with dark eyes and black hair, a face both beautiful and sad, Miklós has been loved by many. His movements are supple and quick, and you might take him for a reckless driver, but he isn't. His grimaces are masterly; not even his best sentences can convey what his facial expressions and rakish, conspiratorial side glances can. Often he is depressed. Something about him and his mind evokes parody: he laughs back at you in a way that makes you feel like an officious fool. He is at his best when involved in confrontations: as a civil rights activist, anarchist, militant poet, clown, agitator. He is easily hurt, is able to cry, is often petty. When he sets his mind to something, he perseveres to the point of exhaustion. He is—or rather was—capable of proving his points with desperate pathos. He reads—the lines or between

the lines—very fast, and skips to the heart of the matter almost too quickly. He prefers philosophy of history to plain history, giving priority to those not content merely to review the past. Miklós is loyal to those he has loved. People in need of solidarity and support can always count on him. Although few have stood by him, he has almost religiously stood by many: the suspects, the accused, the recalcitrants; young Catholics who prefer jail to military service; young writers, young dissidents, who articulate a whole nation's disaffection and contempt for officialdom. He gives his support even when he disagrees.

In Miklós the romanticism of socialism blends perfectly into the universalism of today's new human rights ideology. His destiny is social commitment without democracy, which narrows his prospects or, at best, forces him underground. Yet, democracy without social commitment is not for him either. Miklós has visited Paris, London, West Berlin, and New York but each time returned to Budapest. Dissidents like Miklós are the true socialists of today.

Miklós Haraszti has been my friend for sixteen years. Not having a younger brother, I adopted him as my own. It seems I always need a more radical friend next to whom I can play the conservative dullard.

When I first met Miklós he happened to be under police surveillance. Needless to say, he violated the restrictions placed on him, got arrested, went on a hunger strike, was force-fed, and then was released. Several people raised their voices on his behalf, among them Georg Lukács and myself.

What in fact was his crime? Perhaps holding a seminar

in his own apartment for people only a few years younger than himself. A man in high position, the father of one of the girls there, denounced him. Communism begets and nurtures its own dissidents.

His book, *A Worker in a Worker's State*, caused a nationwide scandal. A former college student, a philosophy major as well as a budding poet and political songwriter, recently expelled from the university, goes to work for a year in a factory, making observations and writing up his experiences. He gives the text to a publisher and some friends, and about eleven copies of the typewritten manuscript circulate in the city. The material is excellent; as a case study it is first-rate—concise, strong, and scathing.

One night a group of us are sitting at a party. At six o'clock in the morning someone rings the bell. It's the police ready to search the premises. Miki has become a suspect. Later, *A Worker in a Worker's State* is declared subversive agitation against the state and he is arrested. They call me in first only for interrogation. Later they search my apartment. I am charged with trying to smuggle Haraszti's manuscript out of the country. But then, since parts of my own diary also qualify as subversion, I too become a suspect. Nonetheless, later I serve only as a witness: our old cleaning lady testifies that my cupboards are kept locked, so others—my nine-year-old daughter or my wife, for instance—couldn't possibly have read my diary. If they could have, I would have been indicted also.

These events took place in 1973, during a wave of counterreform in Hungary. Miki was formally charged. Many testified on his behalf, and his trial became inter-

national news. Reporters swarmed the courtroom. Hungarian-language radio stations in the West broadcast the case. Budapest intellectuals learned Miklós's name, gossiped incessantly about him. Meanwhile, the good life went on in our group of postleftists, posthippies, neo-avant-garde conceptual artists, body artists, sociologists, pre-postmodern filmmakers, semioticists, youth experimenting with every fashionable and dangerous trend and field—a beehive of marvelous, fascinating people, most of whom have since scattered around the world, or committed suicide, or fallen victim to accidents. Those of us who are still alive, although reluctant to talk with others, remember them with romantic nostalgia.

In his book, during his investigation, at his trial, Miki was magnificent. He is a master of such predicaments. Once he was hauled off from a demonstration to a police van. Like a veteran protestor resisting arrest, Miki let himself be dragged on the pavement when suddenly the tips of his beautiful new shoes flashed before his mind's eye. "Oh, pardon me," he said. "I'm coming, gentlemen!" And off he went like a diplomat.

Haraszti's book was translated into dozens of languages, and all at once his name became known among people who followed the news of Eastern European dissidents. At home, of course, it couldn't be published. In the West the young writer's fame grew; in his hometown he was officially a nonperson; in the Young Artists' Club, sponsored and stuffed with stool pigeons by the Communist Youth Organization but still frequented by everyone who wants to meet other young artists, well, there Miklós was regarded as a celebrity, a baron of the opposition.

He was part of the gurus' coalition, too. To be sure, the older gurus looked down on him with irritation. Who is that small, handsome young man? Who is gesticulating there, criticizing and ridiculing us? Is it that Haraszti again? Yes, it's him again, and again and again.

One thing is certain: no state publisher will ever sign a contract with Haraszti, and naturally, an impossible author must reflect upon the nature of possible literature. If my work is impossible, Miki muses, what's the possible like? The naughty little boy, sent to the corner by the teacher, glances back at the others seated at their desks, the good ones. What's missing in me, in the boy in the dunce's corner, in the born dissident? Do they know something I don't? How can they reconcile themselves with reality? What does it take to become a possible writer?

Previously, in a book entitled *Intellectuals on the Road to Class Power*, written with Ivan Szelényi, I tried to examine how the intelligentsia was becoming a separate class in state socialism. The theory that in state socialism censorship is an inherent part, a constitutional and constructive element of literature, gradually expropriated by the elite in power, was in fact inspired by the mood of the mid-1970s. We came to the realization that communism is a system whose power is sustained not by the police alone.

The Prague Spring was over, Solidarity had not yet started, the Hungarian dissident movement was germinating, and Miki was one of the germs. The forbidden, hazardous role he'd chosen provided a strategic vantage point from which others could be observed. The already not-so-young dissident notices how others adjust

their entire behavior and *Weltanschauung* to the fact that they are *legal.* What he sees is more than self-restraint, self-withdrawal, self-mutilation. It's a kind of creative ethos already, an assimilation to a collective and central state ego. Censorship is not mere exorcism but a full religion, the state's religion, created from within. It has by now become a kind of life's blood: Without it nothing can survive or grow. In state socialism one never talks about the writer's freedom, only about the writer's responsibility. He who talks about freedom is irresponsible.

In his new book Miki writes as if he were the conscience of the state writer, a conscience so bizarre that it couldn't really exist. It is possible only because Miki decided to write—in the skin and sometimes in the voice of a state writer—a kind of samizdat minimanual on the aesthetics of censorship, blabbing the state's inner secrets. Haraszti's irony contains an almost diabolical vision: What would happen if state socialism became the civilization of the world? Would it be like the triumph of Confucianism in ancient China or of Christianity in medieval Europe? This thought might have occurred to him much as *Nineteen Eighty-four* did to Orwell.

Haraszti's nightmare is simply this: If state socialism keeps expanding and co-opts every kind of criticism, how does a skeptic speak? A clown reveals the circus director's philosophy for taming animals and keeping order under the Big Top. Meanwhile he realizes that he also happens to belong to the troupe. Miklós, the dissident, claims that dissent is doomed, that every dissident is crazy. And yet, he persists.

And then Solidarity came, and then Solidarity went;

then it was Brezhnev, now it's already Gorbachev. Movements, crises, reforms, crackdowns, liberalizations—but the dominant role of the party remains the sacrosanct *sine qua non*. In state socialism this is the basic of basics. He who agrees to being controlled exists; he who does not ceases to exist. Haraszti does not exist. Nor does the writer of these lines. In the meantime, Haraszti has become an editor and contributor of *Beszélő*, the most important samizdat periodical of the Hungarian democratic dissident movement.

A few months ago Miklós's mother was beaten to death by somebody who left bloody fingerprints on Miklós's manuscript. The funeral was held; the murderer was caught. He was one of the madmen of politics, a young man Miklós had rejected as a disciple. A Dostoevskian character murdered Miklós's mother, that charming, elegant old lady with sparkling eyes, a radical who regarded her son as not radical enough. For people who are capable of bludgeoning someone's head with a truncheon or a hammer, Miklós seems so alien that he automatically provokes aggression against himself.

Go away from here, I told him at the time. This is not a good place for you. I've learned by now that he will never leave. He wants to prove it here. Prove what? His truth, of course. For in Budapest there is a powerful, sensitive truth called Miklós Haraszti.

Although in this book he writes in paradoxical and parodistic style of the state artist and state literature, nowadays, he warns me, it's better to write only one's own ideas instead of condensing other people's into a mischievous theory. Nevertheless, I have never read a more brilliant essay on censorship and the state than this

slim volume of reflections by Miklós Haraszti. It will be quoted by a multitude of American graduate students in sober dissertations. It will be a classic on the recommended reading list of sociology professors. It will be an indispensable addition to Central European studies, too. And to Central Europe as well.

Here in Central Europe, however, even the literary pantheon is state-controlled. Therefore, this intelligent, humorous, vulnerable, magnanimous, overscrupulous, and overemotional man—who is considered arrogant although he is growing ever so gentle—will have to assume his rightful place here only belatedly.

Budapest
October 1986

Translated by Clara Györgyey

The Velvet Prison

The terrifying thing about the modern dictatorships is that they are something entirely unprecedented. Their end cannot be foreseen. In the past every tyranny was sooner or later overthrown, or at least resisted, because of "human nature," which as a matter of course desired liberty. But we cannot be at all certain that "human nature" is constant. It may be just as possible to produce a breed of men who do not wish for liberty as to produce a breed of hornless cows.
—GEORGE ORWELL

Art is not afraid of dictatorship, severity, repressions, or even conservatism and clichés. When necessary, art can be narrowly religious, dumbly governmental, devoid of individuality—and yet good. We go into aesthetic raptures over the stereotypes of Egyptian art, Russian icons and folklore. Art is elastic enough to fit into any bed of Procrustes that history presents to it.
—ANDREI SINYAVSKY

I

CENSORSHIP WITHOUT VICTIMS

THE NAÏVE CONFIDENCE of Milton, for whom total censorship was neither desirable nor attainable, would strike many people today as utterly absurd. Milton believed that such censorship was a fantasy, a feature only of "Atlantic and Utopian polities." Its imposition was an impossibility in the real world. In the wars of Truth, Falsehood was destined to be defeated. Censorship was a "fruitless and defective" weapon whose use would promote what it was intended to prevent. His splendid arguments, which were convincing for so long a time, have been swept away by the avalanche of totalitarian socialism in the twentieth century.

Censorship is no longer a matter of simple state intervention. A new aesthetic culture has emerged in which censors and artists alike are entangled in a mutual embrace. Nor is it as distasteful as traditional critics of censorship imagine. The state is able to domesticate the artist because the artist has already made the state his home.

This book is about the aesthetics of censorship, the

symbiotic relationship between artists and the modern socialist state. It examines the effort by the state to control the culture over which it presides and probes the complicity of artists and writers consigned to collaborate with the guardians that govern the society in which they live and work. I was born into this new culture, and I live in a country where, for many years now, practically nothing has threatened the hegemony of state control. I consider Hungary, among all of the socialist countries, to have played the role of precursor, pointing the way toward a higher, more mature stage of what Victor Serge once called the "Regime of Directed Thought." Hungary's worldwide reputation as one of the most moderate and open of all socialist countries makes it a model, for it is both typical and more evolved than the others.

This book is intended to be neither a sad collection of anecdotes of the censored nor an academic analysis of an evil system of surveillance. These two approaches, which tend to be favored by specialists on Eastern Europe, succeed only in evading the more important questions: Who makes this culture? Why? How? Why is it so durable? Is the presence of overt or covert terror a sufficient reason for its survival? Is freedom really necessary for art to flourish?

I would prefer not to characterize this culture as one of censorship. To do so obscures its novelty: properly understood, ours is a culture that paradoxically seeks the elimination of censorship. I want this book to be seen as an account of profound cultural change. Our new civilization is light-years away not only from genuine artistic freedom but also from traditional censorship, defined as a denial of freedom.

It is not that one does not encounter state meddling in the arts—the traditional form of censorship—in the socialist countries; rather, such meddling is no longer used to silence opposition to the state but to ensure that intellectuals will more effectively perform their proper role. Moreover, such interference is felt by today's intellectuals to be less onerous than it was in the past. If one were to eavesdrop on the conversation of artists and writers as they gather for their mid-morning tea at any of Hungary's country villas reserved for intellectuals, or on the chitchat of high-ranking functionary artists after an official conference, one would be surprised to hear the satisfaction with which they tell each other about their "misadventures" with the state. For censorship is the final glaze that the state applies to the work of art before approving its release to the public.

The old censorship is increasingly being superseded by something altogether new, less visible, and more dangerous. The techniques of the new censorship are fundamentally different from those employed by classical censorship. The heavy-handed methods of the past are pressed into service only when the new ones fail to function properly. That this occurs relatively rarely in Hungary testifies not to the state's liberalization but to the growing success of more subtle means of constraint. Traditional censorship presupposes the inherent opposition of creators and censors; the new censorship strives to eliminate this antagonism. The artist and the censor—the two faces of official culture—diligently and cheerfully cultivate the gardens of art together. This new culture is the result not of raging censorship but of its steady disappearance. Censorship professes itself to be

freedom because it acts, like morality, as the common spirit of both the rulers and the ruled.

Our rulers impress this upon our minds time and again. In the past, censors never dreamed of justifying their acts of suppression by boasting of the many battles that had been fought for cultural freedom. Even the bloodiest terror did not give the old-fashioned dictators the sense of security that would permit them this joke. Of course, the joke works only where it is not funny, where the ideology of censorship has absorbed the ideology of the censored, where tyranny has learned the language of its victims, where the existence of censorship is based on a lasting identity of interests between censor and censored, where censorship (if it has its own office at all) is not the simple oppressor of those who create culture but is their natural home.

If I still speak of censorship, what I refer to is not merely certain bureaucratic procedures but the whole context of culture, not just state intervention but all the circumstances that conspire to destroy the basis of autonomous or authentic artistic activity, not just political *diktat* but the individual's *Weltanschauung* within an all-embracing and unified society, not only "legal" and "illegal" restrictions but also the secret psychological sources that sustain the state's reach even in the last cell of culture. Hence I will refer not only to punishment but also to reward and sustenance, privilege and ambition. I wish to describe the kind of censorship that is not the skin of our culture but its skeleton. I am interested not only in the outer regulations that restrain the artist but also—and primarily—the inner gravitation, the downward pull, of the artist's imagination.

Artistic production has boomed under communism. Never in the history of Eastern Europe have more pieces of art been exhibited. The writers' official country retreats, the studios, the theaters, and the artists' colonies are jam-packed, and should there be a need for more, we would get them. The supposedly unbearable fact of undeniable censorship has compelled not one single artist to refuse any state honor or decoration. Of course, some of the grand old men, heroes of previous censorship trials, are still around, but for the most part they are just as willing to participate in the new culture of censorship as is the younger generation of artists. The persecuted artist is, on closer inspection, just not that unhappy.

The truth is this: untouchable taboos, unlivable lives, unspeakable utterances, unformable forms, the perpetual abortion of unthinkable thoughts do not make us aesthetically sterile. The edifice of art is built out of the very barriers put before it by the state. We skillfully reshuffle the furniture around the walls of the house of art. We learn to live with discipline; we are at home with it. It is a part of us, and soon we will hunger for it because we are unable to create without it.

Pioneers of the Past

Naturally, under totalitarian socialism, as in any ascendant culture, anachronistic characters can be found. They rebel against prevalent values, or they look for a nook in the institutional shadows where they can indulge their

ideals. Only when the state criticizes or punishes them do they achieve a certain fame. But even that recognition cannot be seized; it is only awarded. Publicity given to resistance is usually decided by those in power, for pedagogical purposes. If we get to know these people, it is not because our controlled culture is too weak to digest them thoroughly. They can be born, survive, and be known to us because there are two civilizations—one of the West and one of the East—which confront each other in an atmosphere of uneasy renunciation of armed conflict. They are rootless, just like those unknown "Greeks" who might have existed during the Dark Ages.

These rare birds are in fact the intellectual progeny of a vanquished civilization whose promise of democracy, individualism, and critical thought has left a lingering, though fading, trace. Natives of the new culture, they can only have heard of the old one in a muted fashion. Their fealty to the old—and obstinacy in the face of the new—betrays their real origins. They seem to be heretics against the new consensus; however, their place is defined less by their political ideals than by their refusal to relinquish their intellectual autonomy. They consider this autonomy precious and follow its calling. This attitude automatically excludes them from the new culture and is the negation of the ethos that informs and sustains state socialism. These picturesque orphans herald nothing but their own demise; they are representatives of a dying species, unable to reproduce themselves in the new world that is rapidly rendering them extinct.

My solidarity, naturally, is with this species which so tenaciously clings to notions of personal autonomy. They still speak of censorship when they search rest-

lessly for words that will describe their condition. What else can they do? Rummaging amid the wreckage of another civilization, they select a utopia from the quiver of freedoms that emerged from feudalism. Deliberate anachronism is their only chance for independent action. Rear guards of human rights, they imagine themselves in the vanguard.

Advocates of human autonomy, whether socialist or not, are mistaken if they regard their passionate and periodic protest as a sign that history is coming to its senses. The new culture of totalitarian socialism has not given observers any reason to accord sociological necessity to these atavisms. I fear that the autonomous spirit is not a necessary product of any institution, class, or social relation in the new society. And if this is so, then we have glimpsed the (perhaps only symbolic) sentence of death passed upon these outcasts. Like the peasant who sows on the shore at low tide, they are victims not of circumstance but of their own character. Their lives may be assured only because the two superpowers have so far forsworn each other's annihilation. From spies and traitors they are turned into truants and lunatics. Political trials are replaced by psychiatric hearings. The price of such progress is the sacrifice of social legitimacy; this is the triumphant everyday normality to which détente has given birth.

A handful of romantics exclude themselves from the new culture only in the eyes of the other civilization. They can influence the real culture of family, school, and workplace about as much as a malfunctioning traffic light affects the life of a city. Telephone calls wake up the controller in the central switchboard, a repairman is sent

to reconnect the faulty circuit, and a policeman provides the service himself in the interim.

Perhaps I should stop here, for I have confessed everything. Whether censorship is total or nonexistent, art and power are not natural enemies. Art flourishes, even within totalitarian regimes. Is more proof needed to support the official theory of freedom? Further, the change in institutions and in people's minds is irreversible. Our new culture is made up neither of forced labor nor of a cunning fight for freedom, with secret pieces of "real" art characterized by intellectual sabotage and far-sighted compliance. The institutions and the people belong to each other. True, artistic inspiration is not free from constraints, but is it free anywhere? The censorship of state socialism has its own aesthetic, much of which it has learned from the very artists it desires to control.

Many, of course, prefer to believe that the poet will write a poem that he does not like because of the threat of imprisonment instead of accepting the much simpler truth: art is not wedded to freedom forever and always.

2

ART AND FREEDOM

RUMOR HAS IT that freedom is an essential condition of art: that anything which severs art from its anti-authoritarian essence will kill it; that the true artist is an individual who is independent, at least in his own creative process; that art is false unless it is autonomous; that art means boundless sensitivity, unrestricted imagination; that art is the graveyard of prejudice, the fabulation of reality, form that thinks itself, sensibility that forms itself, incorruptible despair, uncontrollable pleasure, a mysterious magic lantern, a door slammed for the sake of the sound; that art is permanent revolution.

These notions are actually quite recent. Only since the middle of the last century has art been seen as synonymous with anti-authoritarianism. Only then did art become the recognized symbol of the protest of individual consciousness, questioning the order of the world. That artistic autonomy could be an end in itself was part of the promise of bourgeois civilization. But the period in which this promise was made spans only a fraction of the history of art. We have only to recall the art of the ancient Egyptians and Greeks to realize that art without anti-authoritarianism is possible. Does it make sense to

complain of a lack of freedom in the art of medieval Christendom?

Still, the belief that art inherently resists authority and protests power is widespread. The idea persists that, in the end, art is unalterable. Many people regard the pervasive presence of art in our new socialist civilization, whatever its aesthetic merit, as a hopeful sign. They continue to believe that art is the conspiracy of freedom, and that while it is natural for dictatorship to oppress the intellect, so too is it inevitable that intellect fight back. The optimistic outsider imagines that power and art are spheres which intersect only in front of the firing squad.

That such ideas still linger suggests that the many decades of totalitarian socialism have not been enough for its cultural consequences to be acknowledged. But there has been too great a transformation in our part of the world for the nature of art to have remained unchanged. Something more pernicious than the temporary restraint of modern art's anti-authoritarian impulse has been achieved: the need for artistic autonomy and expression has been largely eliminated. And this result has occurred with the cooperation of our artists. Few, of course, would openly confess that they and their friends are accomplices in their own oppression and exploitation. But in reality our artists, despite their worries, gratefully accept society's attention and revel in their own effectiveness. Just as dignitaries of the Middle Ages believed their faith to be the same as that of the Crucified, so too do these artists consider themselves, even as state employees, to be apostles of freedom.

How has this been achieved? In the early years after the advent of totalitarian socialism, both the bourgeois

who had repudiated the *ancien régime* and the artist who had rebelled against the bourgeoisie appeared to be the guardians of the same (now lifeless) spirit. But this alliance was temporary and was based on an illusion. Autonomous art had neither the inclination nor the strength to protect itself. It was dislocated by the ceaseless growth of state monopoly. If art belonged to the masses, whose interests were represented by the Party, art could no longer be regarded as the special province of artists. Yet many artists insisted that socialism was a victory for the freedom of unfettered spirit. In fact, freedom was done away with once and for all. In the event, anti-authoritarianism was a conceit that was unable to survive its own triumph. But art lived on, and even flourished.

Thus, art itself is perhaps eternal, but this kind of good news is solace only for those who are waiting to make contact with beings from outer space. Before we demand aesthetic neutrality from those states that employ their artists, before we demand autonomy for their artists— their respected employees—we should try to imagine what it is like not even to be understood: to be viewed in the way the future views the past.

A Short History Lesson

There are some who will never forgive Marx for his mistaken belief that civilization's turning point—the overthrow of the bourgeoisie—would be accomplished

in an exemplary revolution exactly where the bourgeoisie was strongest: in the advanced industrial democracies of the West. Marx's error was rooted in his benevolent optimism: he believed that the transition from capitalism to a planned economy could only come about in conjunction with the development of democracy, just as it had at the birth of industrialism. Nowadays any child will tell you that there is no such inevitable link between the two. On the contrary, socialism succeeds with revolutionary speed only in the poverty-stricken parts of the world, not as the fruit of democracy but because of its absence.

Expanding capital colonized traditionally despotic societies. Capital secularized these feudal, patriarchal, or tribal societies and pushed them toward modernization. It transformed small sections of these societies into a bourgeoisie and a proletariat. But the anti-authoritarian spirit of democracy, which in the industrial societies had become a strong tradition independent of its origins, was stillborn in the backward societies. Nevertheless, even without the presence of a significant liberal bourgeoisie, capital felt at home in the state market of modernization that despotic societies offered.

In the wake of movements of capital from West to East came ideas of secular redemption, articulated in the seductive language of economic science, causing deep stirrings among the restless intelligentsia. Marx promised a rationally planned society, without crises or class struggle, and he suggested that the discontent of working people would be this society's midwife. Marxism was a shortcut to modernization. It was an ideology more compelling to the impatient intellectuals of the impoverished

East than to the politicians of the wealthy and pluralistic West. The revolutionaries sidestepped dilemmas of morality and sought to pit force against force. Radical lawyers, teachers, students, priests, artists, and writers broke away both from the old masters and the new. They requisitioned the ideas of the strong state and strong industry from their unworthy guardians, appropriating them as the hope of the oppressed.

Marxism's ideology of thorough restructuring appealed to many people for whom capitalism had been discredited by its alliance with feudalism in their countries. They hoped to save democracy from the ravages of capitalism. But Marxism also offered convincing arguments to those radicals who rejected liberal democracy altogether as a fraud. For them, democracy meant simply the elimination of private property. They interpreted the principle of the majority as the primacy of planning and ignored any principle of protection for the minority. Bourgeois liberties were considered as tactical weapons, or else a fraud. These people were self-sacrificing and thought of revolution and discipline as if they existed for each other. They demanded sacrifice and commitment. They rejected all social and spiritual improvements that were not directly connected with organization and power. They saw their own clandestine cells as the kernel and model of the new society. Crises and defeat in World War I revealed the vulnerability of the existing order, causing many ordinary people to drift toward their leadership.

But let us not become too engrossed with the history of the political avant-garde of the planned society and the powerful forces that brought together utopianism,

social science, and the working-class movement. It is enough to observe that the weaker the spirit of democracy, the more readily did the needy, the guilty, the freedom-seekers, and those longing for security let themselves be guided by the provident science of socialism.

So "science" organized the workers' "own" state like a factory. The economy, the administration of labor, political life, and cultural activity were unified into one hierarchical organization. The state apparatus, now the owner of aggregate capital, became synonymous with the intelligentsia, the guardian of all social, economic, and cultural knowledge. (In the East the term "intelligentsia" traditionally applies not only to "creative" cultural professionals but also to those whose work requires higher education.) Intellectual activity and the structure of the state were like muscles and bones in an indivisible, organic unity.

Today, those who had the advantage of education and professional training are members of a secure, organized middle class. Leading technocrats and experts form the upper class, enjoying undeniable privilege. All the intellectual professions have been given political responsibilities; since everyone is a state employee, an objective bureaucratism conceals the class egotism that governs the distribution of goods and the machinery of publicity. In this modernization of society the intelligentsia had nothing to lose but its independence; in return, it gained half a world, and possesses it on condition that it protects the unity of this world and interprets its own power as service.

Did art have any chance to retain its anti-authoritarian nature in this kind of revolution? Artists, as organizers

of emotional life, played a key role in effecting this transformation. Powerless before the revolution, they now find themselves at the heart of power, enjoying the new intellectual excitements of providing for the people and organizing their unity. Few can resist the high prestige of a state artist, who has now become inseparable from his new public—the middle class, which helps to run the nationalized economy and its culture. He is not only a member of this public but also its intellectual guide. Artists, as a group, have become a part of the political elite. They are loath to give up the attendant privileges.

All this has had consequences for the artist and for his art. His thoughts, his sensibilities, his moods are no longer a private affair. Nobody seems unduly dismayed by the fact that the early revolutionary artists learned the intense emotions necessary for their struggle from the works of independent intellectuals of the old order. The figure of the independent artist is now to be found only in the waxworks museum, alongside that of the organized worker. Independent art is impossible because there is no independent audience. We live in a society in which anti-authoritarian art would be rightly condemned as anti-art.

3
THE PARADOX
OF TRADITION

THE VICTORY of socialism brought the free prolifer-
ation of artistic tradition to an end, but this does not
make our culture antitraditional: it respects tradition
very much. Socialist culture has given tradition a final
shape. No new tradition has been invented—that
would be an impossible achievement even for our crit-
ics and historians who meet each year in state-
sponsored national conferences—but our culture has
freely selected from the past. It has chosen one tradi-
tion out of the many varieties as its own and, as such,
this tradition is the only one worthy of survival. In the
past, tradition meant the totality of creative forces and
a permanent readiness to absorb unforeseen dimen-
sions. Today, our tradition enshrines only one dimen-
sion, namely, the one that "points toward the future."
The favored tradition, which is the basis of our socialist
culture, is the protest art and literature of radical com-
mitment of the late capitalist era.

The Management of Tradition

The category of committed art is not nearly as narrow as some might think. Indeed, it is extraordinarily elastic. As socialism consolidated its rule, grew stronger and more confident, the gates to the palace of art opened wider. The family of socialist art's natural ancestors grew as well. All art, of whatever period, which embodied discontent, alienation, indignation, pity, longing, loneliness, suffering, however subtle, was given permission to enter. On a case-by-case basis, of course. Our culture proved strong enough to accommodate and homogenize this varied material. Everything that might conceal art's "revolutionary aspect" was stripped away. The more confident our culture became, the more it recognized just how much it is a continuation and a redemption. The posthumous and selective admission of the past is evidence that our culture is a missionary one: it searches for well-meaning pagans.

Slowly, the criteria for admission have broadened: from militant political commitment to militant humanism, then further toward a general polite humanism, and then finally the humanism of weakness is embraced as well. Eventually the concept of "the human" excludes only what has been created explicitly against the planned society: art for art's sake, art in the name of anarchy, art with antisocial tendencies, art created out of contempt for the ethos of socialism—in a word, art created in order to be excluded. Anything that can be

co-opted will be co-opted, sooner or later. There is plenty of time!

Tradition belongs to those who cultivate it. It is the task of our zealous intellectual apparatus to recommend a tradition, and that is the easiest thing in the world: one simply defines the central core. Naturally it will contain what the state wants it to contain, namely, the implication that the state is goodness incarnate. There is no need for passionate inquisitors, only for ordinary literary and art historians, aesthetes, critics, failed writers, artists, actors, directors—in other words, a group of learned people who have always wished to direct art. State management of tradition is their paradise. And here is the paradox of this tradition: the patriarch of our state culture, the revolutionary artist, was someone on the margins of society, or at least an independent spirit. These dissenters to the dominant values of their time—such as the young Gorky, the young Mayakovsky, the young Brecht—were part of the tradition of anti-authoritarian autonomy; even in serving a political cause with their art they gave expression to their personal autonomy. But later they played the role of state dream-interpreter. The only remnant of their original independence today is that we, their heirs, although organized and employed professionals, do not have to go to the office every day.

Many see an unbridgeable gap between the apparent values of our tradition and the actual values of our directed culture. Some observers of this paradox even speak of falsification or betrayal. Although it may be difficult to believe our present-day directed art when it boasts of such a noble lineage, a direct path led to it from the political art of our predecessors. Despite putting an

end to pluralist culture, state socialism is deeply in-
debted to it; indeed, our directed culture is freedom's
own offspring. We are kept on course not only by the
cultural police but also by an organic tradition. There
has been neither a betrayal of the old pluralist culture
nor a falsification, only a banal, productive metamorpho-
sis. After all, is there anyone so deaf that he cannot hear
in Byzantine churches some echo of the Catacombs?
What could be more natural than that just as martyrs
made paintings for martyrs, latter-day bureaucrats paint
for bureaucrats?

Let us then consider those aspects of prerevolutionary
radical aesthetics that have now bloomed so bright that
they are almost blinding. Doubtless we shall stumble on
some of the sources of state culture's vitality.

The Reign of Values

The relationship between the socialist movement and
the art of commitment has always been closer than even
that of an army and its weapons. Socially engaged art
and the ideal of revolution complement each other in the
choreography of history. Eventual recognition of their
compatibility was the result of an inner affinity.

By the turn of the century there was hardly any sig-
nificant artistic trend that was at peace with the prevail-
ing values, life styles, and institutions. From the era of
Romanticism to that of the Bolshevik Revolution, art
and literature became a swelling chorus of antibourgeois

contempt. Art was no longer bourgeois, except to the extent that it was still part of the market economy.

All alienated artists dream of living in a world where noble values rule, directly or with the least possible mediation. This dream is shared by the diverse currents of intellectual opposition to commercialism. But it is the artist who is most desperate. He finds it more painful than most that, in the eyes of society, he is not valuable except to the extent that he is marketable. He cannot help but detest a society in which art is taken to market instead of being respected and preserved, as in a church. The entrepreneurial society gives the artist the most total, dynamic freedom art has ever known. But its commercial indifference to genuine values makes this freedom hypocritical in the eyes of artists. It conceals their constant humilation. The most vulgar principles rule over the most elevated motives. Everything is unjust!

Revolution touched the hearts of artists when it demanded the rule of *real* needs. For artists this was not a vague prescription at all. Real needs are the precious ones. They have a chance to permeate life only if the creative man becomes society's spiritual leader, when he is honored and cared for, and when others gratefully accept the values he embodies. Where the bourgeoisie is too weak to buy his art, it is even more imperative that it be written off. The valuable ones must take the cause of values into their own hands.

A Little Materialism

The reign of values—socialism—is of course not a bodiless spirit, nor is the artist. Even the reign of beauty must be a real domination; otherwise how could beauty effectively prevail?

The earliest anticapitalist artists, the Romantics, still nurtured a nostalgia for the patronage of the royal courts. Socialism succeeded in seducing artists from the past into the future only with the promise of a powerful and honorable incorporation. Is it so unimaginable for artists to think in terms of a "seller's market," or of the security and dictates of corporate production?

It is not likely that artists wishing for a new world would have prepared themselves for their historical roles with such cynical materialism. Perhaps they did not anticipate that the guardian of values would take the form of a monopoly of state artists. But, as a vanguard, they certainly knew that their values could govern only by becoming the values of the government.

Socialism offered solutions to their material and spiritual problems. How could they object to a future state that *needed* artists and whose tastes artists would dictate? They would have expected, and rightly so, that such a state would not expose them to the impertinences of the market. Of course, some artists may have had vague anxieties about their independence, but in their commitment they envisaged a joyous service: to serve a society that serves the valuable.

Brecht is an example of how quickly even the most

unruly minds can bring themselves to enjoy the beauty of power, once they have committed themselves to the planned society. The happiness of preparation is surpassed by the joy of execution. Socialism, contrary to all appearances, does not suppress artists' Nietzschean desires but satisfies them, offering responsibility and a constructive role to those people of quality hungry for power.

An organizational framework for imposing aesthetic values—surely an ethical aim—awaited the new state and its artists. But it was their forerunners, the politically engaged artists, who signed the blank check for the Great Project. And nowhere on that check will you note any distinction drawn between the authorization for the domination of values and the domination of the valuable ones.

Art as Radicalism

We have reason to suspect that it was not purely out of altruism that artists feverishly joined the ranks of the revolution. I do not mean to suggest that their social consciousness was awakened solely by the humiliating vicissitudes of the market. Their enlistment was fostered by another affliction, a kind of schizophrenia, which artists had been suffering since the time of the Romantics. Because art had been severed from all its traditional roles, they found themselves imprisoned in their own

freedom. Alienation was the price of freedom. The life of the independent artist was a permanent crisis, and quality culture was confined to a ghetto.

Radical commitment provided an answer not only for the quandary of artists as social beings, but for the problem of the nature of art itself. Artists began to look for a solution that would offer a secure functional basis for art while expanding its freedom. They strove for apotheosis. There was no alternative but to seek an art without compromise; they became radicals.

One species of radical artist, the aesthete, searches for the essence of art while remaining apolitical or even antipolitical. His solution for the dispute between art and life is to drive them even further apart. Art is one reality; life is another. His utopia is that of the unsullied medium of purified sensibility. His work embodies his own particular formula, or method, or principle of pure art. This is true whether the artist is a Malevich, a Kandinsky, or a Khlebnikov. He is a creative solipsist, excluding politics (along with all the other conventions of society) from art. He remains above the fray.

The culture of the socialist state descends from a different species of radical artist, the activist. This artist wants to defeat the outside world not by aesthetic surgery but by conquest. He searches for the fount of human happiness and sees in art the best divining rod. For an El Lissitsky, a Rodchenko, or a Mayakovsky, involvement in politics is a natural consequence of his artistic radicalism. The task of transforming society offers the activist that extra-artistic role for which he hungers as an artist. Politics provides the necessary

chemical agent that art needs to digest the world. His art is in fact a proselytizing cult; it wants to become the soul of the community.

Both the desire to cut through the chaos of media to a purified, perfected expression, and the desire to cut through the chaos of humanity to the perfect society are rooted in the revolt against a fragmented world. The first impulse creates successive artistic revolutions, proclaiming ever newer final answers to the question: What is art? The second impulse leads the artist to socialism, which, more than any other "ism," promises a reconciliation between the artist and society.

Thus it was that the real strength of political art manifested itself. What previously looked like one hopeless project of transcendence among others—that the artist should speak in the name of a historic plan—now was possible. The novel fiction that the artist should have social aims and allies now mobilized a real public. And the activist, true to his artistic radicalism, did not recoil from his discoveries. For him, society was a work of art, and politics his palette. It became simply a matter of professionalism to find the greatest artistic pleasure in seizing political power, abolishing entire social classes, and creating a unified culture.

The secret credo of all radical artists, whether aesthetes or activists, was voiced by socialist artists when they denounced the spirit of tolerance. They could not be angry with the world without being angry with its permissiveness. Tolerance became doubly valueless for the artist—even though he owed his freedom to it. In the form of the market permissiveness insults the artist; in

the form of pluralism it presents the world as infinitely malleable, depriving reality of a single palpable heart. But radical artists can find salvation only if they can pierce the heart of reality, their archenemy.

As one can see, the St. George of art takes from political theory only his lance, and from the socialist movement only his steed: his faith is all his own. The aesthetics of commitment was invented not by bureaucrats but by alienated artists.

The Realization of Art

Modern art, then, was utopian. It had aesthetes and activists; both were haunted by the same radical dream: to realize art. In wave after wave, the utopian aesthete tried (and still tries) to triumph over life without resorting to politics.

The socialists insisted on the futility of such efforts. Lacking a social base, they charged, the intelligentsia tries vainly to legitimize itself through aesthetic means alone. Wallowing in its own bitter independence, it seeks to lift itself above the mud of bourgeois culture by its own hair.

The nineteenth-century appearance of *l'art pour l'art* was the first attempt of the aesthetes to resolve the prickly relationship of art and reality. Since then, under the banner of celebrating an art about art and the artist, scores of apolitical models have arisen. From

Rimbaud to the Velvet Underground, experiments in bringing to life manifold gestures of intellectual idylls and self-destruction, as well as refinements of artistic ways of opposing society, were all elevated to the rank of art.

They too hated the bourgeoisie and they too were full of utopianism. But because they wanted a new world built only out of their own personalities, they were accused of being insufficiently radical. A culture of the intelligentsia whose only object is the intelligentsia is still bourgeois, the socialists claimed. Of course, none of the accusers could have hoped to shame or provoke the aesthetes with this accusation had it actually been true.

The Elimination of Art

The political artist is thus a genuine Founding Father. Independently he gives the same twist to art that Marx gave to philosophy. Without a qualm he exchanges his wizard's robe for the lab coat of the social engineer. In pursuing the greatest utopia of individualist art—its subjugation of life—he does not hesitate to trespass upon his own autonomy.

It is precisely because of this that art's realization also meant its elimination, just as philosophy's did for Marx. Political artists, from the Futurists to the Proletkultists, while squabbling furiously among themselves, were equally proud of having done away with art. As Rodchenko and Stepanova wrote in their Productivist Mani-

festo: "The collective art of today is simply to lead a constructive life." Countless manifestos began or ended with the slogan, "Down with art!"

But just as there were two options—the aesthetic and the political—for the realization of art, so too did they exist for its elimination. The strategy of the aesthetes was the strategy of silence. Susan Sontag, in her essay "The Aesthetics of Silence," described a number of constraints on artists that led to silence, but she omitted one: the escape from the political option. Those who wanted to turn art into life without resorting to political commitment could choose only among the variations and innovations of silence.

"If I am just another seller among many in the marketplace, then I offer silence," says the artist who is on the brink of commitment. "Art, if it is *only* art, is sheer impotence." In this dilemma of efficiency versus silence both sides naturally believe that the other's strategy for the elimination of art is wrong.

And how else could art *efficiently* eliminate itself except through a political movement? Like the ecstatic liberation of the soul from the body in some ancient religions, politics provides the artist with a public role, an ethos of service, as the only possible path to art's realization. Commitment entails obligation. In exchange, the artist receives a prize from the revolutionary movement that he painfully lacked when he was free: the satisfaction of being truly needed. However small the socialist movement may be initially, it always considers the artist its own. Thus, it proves that the utopia of art-becoming-life can be realized, if only in embryo. The new world adjusting itself to prophetic art can be glimpsed in the

movement which—sooner or later—will reward the artist with the whole of conquered society.

Art and Revolution

"While the true revolutionary is not always an artist, the true artist is always a revolutionary," declared a famous Hungarian novelist, Tibor Déry. Any of his Eastern European comrades could have made the same statement. He defines art through revolution. Here is an example of the anti-authoritarian tradition in its most militant form, as it turns upon and begins to devour itself. But one would be wise to suspect that he would not use the metaphor of political revolution if it were nothing more than a metaphor for him. Instead, he considers it to be the artist's *duty* to fulfill his revolutionary calling.

Presumably the revolutionary artist sees as beautiful everything that serves the revolution. But he believes this only because he is convinced that not everything that others regard as beautiful *is* beautiful. How self-evident—and how self-revealing—is the term *true artist*. The adjective conceals the future of commitment: it alludes to a revolution that would not deserve the name if it tolerated any and every kind of artistic effort. The revolutionary artist is *not* the artist of permanent revolution.

Art and Politics

There is yet another way of reading Déry's remark. It has an air of contempt for ordinary politics, which trifles opportunistically with the all-or-nothing politics of art. This is not only the vanity of a Founding Father; the remark harbors a certain unhappiness with the movement whose membership he cannot refuse because it is the only way that his dream of the New Man will come to life. Faint echoes of the artist's independence can be felt in this disdain. But what is most remarkable about this sentiment is that it does not wish to break the ties that connect art to politics; rather, it longs for a reversal—to make politics dependent upon art.

It is a painful bond and its nature is such that every shiver of unease only pulls it tighter. Political artists most admire the revolutionary politician who lets it be understood that his love for politics is also unsettling. Lenin spoke to their hearts when he confessed that he was afraid to listen to Beethoven because when he did, he felt like caressing people's heads when it was necessary to beat them. "How true!" the writer of these lines, moved by emotion and self-pity, had thought when he still aspired to be the Lenin of the arts.

Just as the most deeply religious are moved to become priests—God's functionaries voluntarily serving simple sinners out of a higher devotion—so too does the artist of the New Man shoulder the burden of ordinary politics. But eventually state culture with its banal routine effaces the original revolutionary exaltation still felt by

some artists. Where are the holy tribulations? The martyr's rapture is not easily rekindled. But he tries. The consolidation of the New Order paradoxically gives rise to a few new "radicals." They label as "bourgeois" their otherwise quite reliable comrades; they sniff out "betrayal"; they style themselves as abandoned heroic guerrillas. They are angry on behalf of the new state, not at it. They want the machinery of state to rededicate itself to art, its spiritual vanguard. They demand that no one fail to see, behind the frozen mask of the state artist, God himself sweating in the labor of creating the New Man.

4
THE AESTHETIC
TRADITION

IT IS the paradox of tradition that the social commitment of our early revolutionary artists created the aesthetic conditions for their later assimilation. Today's disciplinarians of art did not materialize out of thin air. The radical artists of the bourgeois crisis of individualism nurtured the latent desires that later assured support for the nationalization of culture. Their fate was to preside over their own domestication. But can a genuine aesthetic culture be built upon such a tradition? Can commitment have an independent principle of form? And can the aesthetics of censorship employ that principle for its ideal?

Most histories of art do not list the art of commitment as a separate entry—partly because art historians' outlook is rarely sociological, and partly because it was hard to take the legitimacy of "proletarian" art seriously—especially since nothing about those aesthetics was in any way created by the proletariat. Moreover, the intent of this art was clearly extra-artistic. In the *fin de siècle*

burst of bourgeois art, it seemed merely one peculiar, largely tasteless bit of madness among many more interesting, more talented artistic experiments. It was dismissed as inferior, derivative, or, at best, applied art. Committed art was as worthless as commercial art. Commitment was castigated as the confession of artists who simply couldn't cut it. Early Christian art in the sophisticated late Roman era must have been viewed similarly—if indeed any notice was taken of the Catacombs below.

Those few who did find committed art worthwhile tried to lure it toward autonomy and away from its love affair with power. Theodor Adorno, for instance, condemned Brecht's optimism as a retreat into the most bourgeois kind of happy ending. He demonstrated the compromising element in the cult of commitment. He saw Epic theater, which was supposed to banish the consumer mentality, as even more calculated in its consumerism. Finally, he felt its tone was didactic in its emphasis on "realism," and its stylized, empty formalism. Still, he defended Brecht against those of his detractors who said that he was a brilliant artist *in spite of* his political commitment. But this defense did not deter Adorno from emphasizing, in his appeal to Brecht, the common critical values of modern art. He did not reckon with the strength of will implicit in Brecht's kind of commitment—a commitment that ultimately would prove incompatible with the ideal of artistic autonomy.

The New Function

Before socialism, the function of art had been simply to preserve its own autonomy, or, in a wider sense, to preserve the possibility of autonomy within society at large. In the culture of social commitment it has a new function: to enlarge, direct, and give cohesion to an organized public, the nucleus of the future society.

The old demand for autonomy is dismissed as a dogma of self-mutilation, a prescription for irrelevance. The notion of public service is this culture's guiding principle. Whoever has embraced this liberating principle will understand that serving the people not only does not spoil but actually deepens artistic pleasure. The idea of commitment helps to deliver the work of the artist to his audience, and gives him the aesthetic basis to mold this public and to prepare the context and reception of his art. Looking at the aesthetic of commitment in this way puts the promise of autonomous art to shame, so retrograde is it where fulfillment and richness are concerned. Thus, after a short interregnum—called modernism—the artist again reconciles himself to History and recognizes that, in serving the public, he serves himself.

The work of art is thus a kind of connective tissue, part of the division of labor, with an internal structure that enables the work of art to fulfill its new function. That function has changed, of course, but it has not been completely severed from its past: rather, the secret of *effective* beauty has been rediscovered. Past art turns out to have been merely a preparation for future art, whose

mission can be summed up in a phrase: to educate. Just as history finds its culmination in socialism, so too does art seek its completion in commitment. But everything has its price, of course. If art is to be a "true reflection" of reality, then art's new function conceals a taboo: we must exclude all art that might suggest that reality is, or sometimes is, nonaligned, indifferent, aimless, absurd, intangible, deaf, dumb, or blind. This taboo is a permanent feature of the cult of commitment. If, before the advent of state socialism, committed art always had to protest reality, today it must always affirm reality. The dream of a world in which only positive, life-affirming, and constructively committed art can exist has been realized. This art neither hates nor worships "reality": it merely denies reality the chance to be mysterious.

The quality of any particular work of art arises neither from its interdependent elements nor from unforeseen innovations. The harmony of its elements is linked to their intent, and this in turn is rooted in their common purpose. They need be neither unrepeatable nor necessarily original. The socially engaged artist is progressive even when he uses archaisms, or popularizes, or borrows, for he has the freedom to ransack the whole treasure chest of past culture. The sign of his originality is his ability to find ever more suitable and imaginative ways of expressing the socialist message.

The media are only important as means to an end; they are not themselves the source of Beauty. It is a counterrevolutionary blasphemy to say that the medium is the message. To cultivate the media for their own sake makes the artist a slave of his medium. The message

emancipates him from this tyranny. The very diversity of media, their malleability and adaptability, is proof that the message is universal. Painters paint, sculptors sculpt, writers write, but none of them should suffer the vanity of thinking that his medium is superior to another's. To be sure, no medium is dispensable. All are needed. All serve the message.

Art is simply one element among many to be used in the creation of the masterwork—the planned society. The artist's efforts are aimed at rendering the enjoyment of art indistinguishable from the appreciation of art's own wish to build society. The mystical heights of aesthetic pleasure thus take place beyond the particular work of art itself, in the catharsis of shared social intentions.

The artist is a social planner. He not only inspires but also organizes his public. Artistic enjoyment is complete, and the work of art judged healthy, only in terms of History. The aesthetic merit of a work of art is measured by the extent to which, in its structure, fantasy world, and passions, it conforms to the needs of concrete social action; otherwise, the artist's commitment would not be credible. Truly artistic works are those in which the socialist message is indivisible from the aesthetic means chosen to express it. The artist must package the message in such a way that the audience experiences it as a kind of revelation. The best package for this purpose is the world itself. That is why the socially engaged artist must "mirror reality." Realism is the most accessible and least distorting way of encapsulating this message.

The work of art must not become sheer rhetoric. This danger looms large for socialist art: it is like the pull of

gravity. Socialist art may be art only in relation to political rhetoric, but the fact that it is "more" than mere rhetoric makes it art. This art gravitates not toward autonomy but toward the message.

Because it is the social influence of such art that this aesthetics considers quintessentially artistic, the artist needs "outside" direction. Critics condemn this need as anti-artistic. But they are wrong. For the first time since the Christian Middle Ages, the public spirit of art is released by this need. And this is not a step backward. Only in the modern planned society, a society owned by the state, will art achieve such an exalted stature. This aesthetic, which is the basis of state culture, has evolved almost imperceptibly. Previously the social aspect of a work of art would have been no more important than any other. Today only the work that expresses a social meaning is artistically valuable.

From the point of view of the aesthetics of censorship, this achievement is more than a fashionable idea; it is a turning point: artistic pleasure, once a private affair, is now the means for social insight, itself complicit in the transformation of society. The idea of commitment, a small, seemingly innocuous step in late bourgeois art, is culturally an enormous leap. Without it, the directed art of state socialism could hardly have come into being, let alone flourished.

5
THE LIBERATION
OF ART

THE VICTORY of state socialism is now nearly complete. There is no significant social life outside the life of the state. Those who insist on playing economic, political, and cultural roles independent of the organization of the "common good" exclude themselves from society. The firing squads of early socialism removed those individuals who had lost their role in society. In the language of the time, these people were condemned as "malignant growths." Today they are "innocent victims"—a phrase favored by the social healer when he at last sees fit to substitute medication for surgical intervention. Those in power first condemned "unnecessary" terror when it started to weaken the very fabric of society. The degree of de-Stalinization is a function of the proportions of "necessary" and "unnecessary" victims; that, and no more.

However, the vast majority of artists were not "parasites" to be removed but were among the "healthy forces." After all, they had worked hard for their liberation, and they were not about to betray it.

The Liberation of Artists

Most artists unfailingly celebrated the rise of socialist power as their liberator. The objection of skeptics that art pursued under these circumstances is not really art because real art cannot tolerate such circumstances is a tautology that collapses in the face of our reality. Indeed, most artists felt that the time for real art had now come. For artists born later, of course, the notion of "independent" intellectual life is simply a recipe for social irrelevance. They understand that the state is the guarantor of their liberation.

In some socialist countries domestic revolution brought the Communists to power straightaway; in others, the Communist Party eliminated Western European–type democracy by relying on the forces of a foreign army. These differences had serious consequences for national feelings but did not affect the integrating power of the new system. Directed culture emerged out of society itself, whatever the language of the army happened to be. Writers and artists became the builders of directed culture without any difficulty because of their prior commitment to a planned society. By the time the Communist Party openly took power, the majority of artists were already committed to loyal service. They enthusiastically believed that their status as artists and citizens would greatly contribute to the elimination of exploitation—more of a liberation for them than a sacrifice.

Many decades have passed since our socialist societies

got their start. Today, since the decline of "unnecessary" terror, art's heroic Founding Fathers reject most of the work of the Stalinist period and declare that they—the propagandists—were misled. But even disappointed veterans will not give up the conviction that guarantees their future: "we have been liberated."

Cause for Enthusiasm

Like workers, artists are now a thoroughly organized and rationally subdivided group of state employees. Their liberation is rooted in this very circumstance. As with the worker, so with the artist: state employment liberated him from the dubious protection of private property. For workers, state ownership of the means of production meant the promise of job security. In the event, socialism liberated the working class not from its chains but from the competition of capital. By this, socialism enabled workers to feel their chains as unavoidable and linked to their own security. Nor could socialism offer the workers an end to exploitation and pointless labor. And yet they cannot be considered wholly dispossessed. As a result of the state's domination over the economy and control of aggregate capital, the governing elite who invest this capital have been able to bring an end to the uncertainties of existence for the working class. But nationalization has made artists happier than it has the workers, and not just because artists

supported nationalization more actively than did the workers. Artists were motivated by an ideological instinct that made them more prone to embrace commitment.

Intellectuals, artists, and writers were not victims of any kind of deception. On the contrary: It was they who shaped the ideas and sentiments that led to the Communist victory. "Hand-in-Hand with the People," "Join the Mainstream of History," "The Progressive Artist Must Seek Out and Create the Progressive Audience"—these were their own slogans. The style of the period, proletarian populism, was their creative—and vastly effective with respect to the workers—contribution to the propaganda of nationalization.

The prospect of nationalization filled artists with enthusiasm. They expected more than simply an end to their private misery and social helplessness. They thought: if society provides the prestige, then art can directly serve society through its humanistic relevance. Not only revolutionary artists speculated in this way. Even many authoritative figures wary of embracing the notion of commitment (Béla Bartók, for example) expected an improvement in artists' social position and an increase in their influence through state subsidy.

The nationalization of art fabulously fulfilled all these expectations. The artistic cause—the common good— was realized in "our films," "our classical and pop music," that is to say, "our art." The artist became a worker for the general good, a *primus inter pares*, in fact. Talent was recognized, in reality and not just in slogans, as belonging to the *whole* of society.

Who can say whether it is giving or receiving that has made the artist happier: he has been incorporated into the organization of a Great Work—the remaking of society itself. He has been rescued from his exile in the limbo of bourgeois independence. He has become an Organization Man, but even if he senses this, he sees it as a sign of his indispensability. He is locked in a warm embrace that has secured him real influence in the formation of a society based on the pursuit of rational ideals. Art's century-old dream—its social realization—has come to pass.

The idea that artists should consider the social implications of their work—indeed, that they should take responsibility for society as a whole—had previously been an eccentricity; now it became a respectable (and inescapable) duty. Society stressed this by providing funds. Personal gratitude, and gratitude for the elevation of art (from the cafes to the palaces of power), intertwined with artists' conviction that the socialist transformation was identical with their own aesthetic interests. In fact, art liberated itself by building a society that at last it could love without reservation.

These sentiments were a lot more widespread in the hard Stalinist times than we would now like to admit. Those times were, in fact, a honeymoon for society and art. The post-Stalinist era would not have been able to transform directed culture into a happy and peaceful family without the memory of that earlier happiness.

Every Restriction Is an Emancipation

The authors have been inventoried. So have the various branches and genres of art. (Critics and cultural historians have suddenly become expert administrators; their secret wish has been granted.) All possible aspects of artistic production (its creation, execution, and distribution) have been accounted for.

Some modern genres were almost ready-made to be regulated. Filmmakers, artists in radio and in the theater, and, more recently, in television, were already employees of a technically and financially centralized industrial organization.

But the other, more artisanal crafts did not get a bad deal either. Whatever the state included on the list of acceptable and necessary genres no longer ran the risk of disappearing for lack of a market. The state guaranteed a public. Regulation was protection. To be sure, the cocoon spun around the artist, first as a kind of frame and later as a casting mold, could interfere with artistic development. Security certainly provides a different basis for artistic development than does the risk concomitant with a free-market economy. A new starting line was drawn, ensuring that, instead of competition, the impartial love of the state would govern careers.

Thus, everything considered "socially relevant" in art was given equal executive representation. Even such esoteric genres as folklore and the avant-garde (each previously created within a small circle of obsessed devotees, almost for themselves) now attained official status. Even

previously unheard-of genres emerged: the mobile formation, involving thousands of people in a stadium; the skit (performed in a factory or cooperative); the *chastushki* (familiar songs whose lyrics have been replaced by texts with a political message). The directed development of socialist culture (regulated in individual artistic departments according to their capacity for internal growth and reproduction) breaks down barriers of "general taste." The planner-artist's imagination wanders into the past and resurrects extinct genres for use in an industrial context. Strict oversight and bureaucratic discipline prevent the genre from stagnating, and the artist from starving. Mass society makes room for each and every specialist.

Nationalization brought about a Copernican revolution in the status of art. Before, the individual expressed his feelings to society; now it is the other way around. Art is a staple of the nation's diet. Flavors and proportions are concocted by the directing bureaucracy, the corps of critics and university lecturers who determine not only the national but also the individual ration.

Gone are the times when the inhabitants of a small provincial town could have a say in the siting of sculptures in public places. During the Stalinist era they were given statues of a buxom Mother and a recognizable Leader; after de-Stalinization, abstract Motherhood and anonymous Progress. In both periods art remained a gift and message of the state, and in both periods aesthetic unintelligibility was made a political offense.

Naturally the new system of regulation can also prohibit, but it does so only in the defense of artists. Prohibition in the strict sense of the word is necessary only in

isolated cases of mischief requiring little financial support, and steps are taken to minimize such occurrences. Private individuals may not import or distribute photocopying machines, which are kept under strict supervision in every office. It is illegal to sell paintings outside official channels, and artistic equipment (from paintbrushes to movie cameras) can be purchased only by those so authorized. Amateurism is regulated as well. It is forbidden to recite poetry or other literature, play music, dance, or mount exhibitions in private apartments, in the street, or in any other unauthorized place. But in the case of periodicals, theaters, film studios, orchestras, dance groups, television broadcasts, and the like, prohibition is unnecessary. Everyone knows that only a state organization may set up its own institutions. Obviously, real artists have nothing to fear.

Those who doubt that art has been liberated disregard the explosion in artistic "production." Beyond any doubt, nationalization has swept away all barriers to creative energy. The growth is substantial, both for individual authors and for the nation as a whole. In some socialist countries, modern art has only just arrived and owes its very existence to the liberation of art.

Directed culture was strengthened by talent-scouting campaigns and by careful support for talented people. Fees are now incomparably higher than in the past; books and movie and theater tickets go at fire-sale prices; state institutions commission works of fine art. The bureaucrats did not aim to silence artists; their only tyranny was generating massive financial support and an insatiable demand for more art.

Naturally, some artists of the old generation were si-

lenced. A prerequisite of liberalization was the construction of a unified culture, employing a combination of carrots and sticks. Most artists eagerly gobbled the carrots; sadly, sticks had to be used on a recalcitrant few. But old-fashioned artists, stubbornly clinging to archaic notions of independence, do not need to forgo the obvious advantages of liberation. Today anyone can see that the new generations of artists are permitted to create works of art that would never have been allowed to see the light of day in the past.

The passage of time demonstrates that nationalized culture can work without the detailed and constant prescriptions of official aesthetics. Culture remains loyal even after the overt subjugation of society has been removed from the agenda. It functions best when it is based not on the state's aesthetic demands but on artists striving to convince the state that their work is acceptable, is adaptable. Compared with Stalin's time, this might be seen as a weakening of control; in fact, it is a consolidation. The blessings of liberation are extended to less committed artists as well—in return, of course, for their loyalty.

Liberating care extends from education to retirement, even as far as an official funeral. No art student need fear the future: the arts colleges have a monopoly, so that the caprice of the picture-buying and theater-going public cannot inflict unemployment on their graduates.

There has not been a single change in the position and prestige of artists that would be unacceptable to the freest artist in the freest world. If only the artist did not have to sacrifice his autonomy and art's arrogance for these gifts! But is it such a high price to pay? Ideals are

important, but in this case it is not even certain that the ideal of freedom conflicts with ugly material advantage.

Rather, one could say that this change makes possible the juxtaposition of individual freedom with freedom from material necessity. The dignity of the solitary artist is replaced by the dignity of public attention; the excitement of irresponsibility by the pathos of responsibility. This process is perhaps like aging, like the menopause of individualistic culture.

The Magic of the Artists' Retreat

The manor houses of the exiled aristocracy have been renovated—the nobility couldn't afford them anyway—staff hired, the heating turned on, and invitations sent out. This is the moment of historic justice: authors fill the opulent rooms. Important assignments, urgent deadlines, or famous names may influence the order in which invitations are sent, but each of us—the registered artists of the nation—will eventually have his turn. Although the number of private villas belonging to once-destitute artists is on the rise, the popularity of the state-owned artists' retreat has not declined. Novices and veterans, composers of operetta and of hymns are no longer separated by an impregnable barrier. Friendly togetherness, studios, desks, and first-class gossip about the apparat and colleagues (elements of an intense yet also tranquil

creative atmosphere) await us. There are flowers in the park, a lake for the poet, a glade for the novelist, picturesque peasant houses in the village—nor is the capital too far away either. Breakfast is served in the rooms, lunch and dinner communally; the dreams of Fourier's productive Phalanstery and the amicable commune come true here. How many film scripts have been written in the wainscoted common rooms! How many poetic empires have been built here! What do they know about freedom, those who have no houses, never mind national artists' retreats!

The Choicest Lotus
Grows in the Marshland

The advent of state socialism heralded a rise in social mobility. This was reason enough for euphoria. Many artists of the first generation had genuinely proletarian origins. They were members of a class to whom education had been denied. Their emancipation seemed synonymous with the liberation proffered by socialism. Even now, after many years of bitter disappointments, one cannot demand that they see clearly the betrayal that was buried beneath the process of revolution they fought so hard to establish.

For they would never have participated at all in culture if its development had remained "organic." They submitted themselves to state direction without regret:

this was the ransom they had to pay. Moreover, they redeemed more than just themselves when they "conquered" culture. They see their own rise as a consequence of the rule of the people, and they have had to continue to insist on this illusion even after the self-critical discovery of "mistakes" and "crimes." The revolution is like a family: no matter how terrible your parents, without them you certainly would never have been born.

It is vital to the success of directed culture that the populist element remain strong. The myth that it is the people who are victorious in socialist art also serves the artists' interests. This myth has remained the basis of art's prestige and prosperity, even now when there is no longer any upward mobility, when the artists of working-class and peasant origin have become a minority, just as have the professionals of similar backgrounds in the economic and political spheres.

Ever since the second generation, the majority of artists have come from socialism's new middle and upper classes; their parents are state intellectuals.

Although a slowdown in social mobility is in the interests of the new professionals, they still cling to the myth of direct popular representation. Our privileges prevent us—more effectively than any political police—from openly embracing the ideology of professional elitism. The absolutism of the elite would be harmed by recklessly discarding a previous legitimacy. Thus, in the arts as well as in other fields, we aim to have our cake and eat it too: to retain both the privileges of power and the legitimizing conceit of serving the people.

Permanent Liberation

But when we reach this stage, our behavior can no longer be explained by referring to the contradictions of the past. The more the great passions of the pioneer period fade away, the stronger the forces that preserve directed culture become. We shall not be lonely. The socialist revolution promised an organized public to the artist at a time when he felt oppressed by capitalist consumerism, and the promise has been kept. This public maintains its hold on us, and its own boundaries are becoming better defined. We can count on the generosity of the bureaucratic class, society's planners. But we can also be certain that they will not hesitate to use force if we, their artists, bureaucrats ourselves, try to escape our velvet prison. Art has become the expression of a class that can see life's conflicts only as justification for its own paternalistic rule and that expects its artists to remind it of its tasks.

I use the official term "liberation" (to describe the elimination of artistic freedom through nationalization), not just for the sake of irony. But hasn't art simply returned to its original home: the establishment? Was not the brief period in world history when the artist was free to hate society a deviation? Weren't artists happiest when they were nothing more than ornamentalists of an unchanging world order from their early youth to their old age? Wasn't the cultural autonomy produced by the Industrial Revolution just an all-too-fleeting dream?

Now that capitalism is bent on destroying Nature, isn't the next step to be the culture of scarcity, of ruthless empires, and isn't this perhaps the real reason for the artist's happy return to the fold of state religion and authority? But I do not want to drive the reader to despair; he probably finds this book too pessimistic, anyway. But the revolutionary dream is definitely over: art cannot remain free and have a secure audience within an organized populace.

Artists, as a group, are today distinguished representatives of the organized intelligentsia, sharing a unified ethos, a consequence of the system of socialist education. We are the blessed ones, the true elite: it is our privilege (and duty, of course) to shape the general taste, to represent the nation, and to determine the uses of tradition. If our I.D. card registers us as "artist" or "writer," every policeman will salute us, even if we are young or shabbily dressed. Today society tenders its respect in exchange for our loyalty. No artist, however mediocre his talent, is forgotten. No work goes unrewarded.

In our new socialist civilization there is a multiplication of interest groups in our daily life. Different sections of the ruling class all want more power. Technocrats and bureaucrats, economic pragmatists and orthodox activists, empire-builders, nationalists, and cosmopolitans all aspire to a greater share of power in the ever-changing repartition of social control.

Art, too, becomes a sphere of "ideological battle." Talent vies for attention and scarce resources. These developments are specific to the context of directed culture; they are signs of the final establishment of our new civilization's value system. Artists regain their personalities,

individuals stand out from the crowd (even as they serve it), but liberation is irreversible: the standard-bearers have become advisers. We are active members of an all-embracing cultural mechanism whose attention is directed primarily inward, to ensure that no one element disrupts the whole. The art of the liberated planners is enriched in an orderly fashion. Creativity is controlled, but it is not snuffed out.

6

A CHAPTER IN
THE STYLE OF
THE ESTABLISHMENT

DEAR COMRADES!

Throughout human history there have been many views on the nature and function of art, but only Marxist-Leninist aesthetics state unambiguously that art is a social phenomenon, produced by man's labor. The artistic process and the work of art itself are all the product and achievement of human labor. Art always mirrors and preserves the historically changing content of human progress. Art, as a specific, ideological form of consciousness, is part of the superstructure, determined ultimately by the economic base.

Art provides an irreplaceable, specific, experiential means of perceiving reality. Art plays a vital ideological, ethical, and psychological role in the formation of the personality. The formation of the New Socialist Man is a great task for the artist.

Our artistic policy primarily supports socialist realist

art; but it also makes room for all truly humanistic artistic values, while carrying on steadfast, principled debate with anti-Marxist tendencies. We must express clearly our ideological position in the arts, on the basis of the politics of alliance. We cannot abandon the attempt to direct these tendencies, gradually and by the power of persuasion, to an understanding and acceptance of Marxist-Leninist ideals.

Such persuasion is the task of art criticism. Our artistic policy opposes by means of prohibition only those "works" that are reactionary, counterrevolutionary, or tasteless, or have only vulgar appeal; to do so is not only our right but our duty. The constitution of the Hungarian People's Republic, for example, provides for and guarantees the freedom of artistic work, but this cannot curtail the socialist state's right to select works of art according to their social and artistic merit.

The existence and harmonious development of the socialist system of art is underpinned by a socialist economy based on public ownership of the means of production. This institutional system is a part of the organization of the socialist state, which is based on the rule of the working class; such a state enforces the objectives of the cultural revolution in the arts under the aegis of the party of the working class. In this social organism the artist plays a most particular role, whether, as in some branches of art, he works in state institutions or, as in others, he is only allied with them.

In past centuries there was a system of patronage, based mainly on private property. Under socialism this is replaced by an entirely new relationship: society's

mandate is conveyed to the artist by people qualified to do so. Under socialism, incentives, commissions, financial support, and recognition of artistic work are part of a deliberate and comprehensive system.

The main types of artistic institutions in our society are as follows: the social organizations that unify the arts; the creative workshops; and the institutions established with the aim of presenting, performing, or publishing works of art. Even the most traditional institution is different from its bourgeois predecessor because it now serves socialist artistic policy.

We shall now describe a few features of this new institutional system.

Creative workshops, with their varied functions, perform a task of great importance in the life of the arts, providing an important link between artist and audience, on the one hand, and, on the other, between the artist's aspirations and socialist artistic policy. In most branches of art the creative workshop is also an artistic forum, and conversely, most artistic forums are also creative workshops. Literary and artistic periodicals, publishing houses, scriptwriting departments, theaters, film studios, orchestras, choirs, ballet companies: these are all creative workshops—as every collective is—which do not merely interpret works of art to their respective audiences but also actively organize and create new works of art.

The primary task of the workshops is deciding which artistic work should reach an audience and what size the audience should be. Similarly, it is their task to favor, using available means, the works of art that convey committed, socialist ideals.

A Chapter in the Style of the Establishment

It is one of the basic principles of our artistic policy that, when artists portray life and social reality, they can and indeed should draw on the most varied forms of expression. The choice of style and form is the artist's essential right, but these will depend on the subject matter of the work of art. What is essential is the work's ideology, the sincerity of its representation.

The other main task of the creative workshops is the continued research and discovery of values and the induction of young artists into artistic life. The workshops, enforcing the general principles of socialist artistic policy, take into consideration local or genre-specific characteristics, too, and also consciously endeavor to help artists increasingly to create in the spirit of socialist ideals. Today, these creative workshops are spread all across the country.

The system of workshops operates on the principles of cultural policy, under the direction of responsible, state-appointed leaders. The independence of these artistic circles guarantees and reflects the consistent enforcement of our principles and is evidence of their more effective, differentiated, and localized application. Therefore, the independence of the creative workshops must be coupled with ideological and political responsibility of the highest order.

The mediating system of institutions is not independent of the creative workshops, but it is useful to consider the mediating function separately. The mediating institutions are comprised of book and periodical distributors, radio, television, movie theaters, concert halls, exhibition halls, although, of course, radio and television are also creative workshops. The relationship between

the work of art and the audience is realized within and by means of these distribution networks.

The important task of the distribution system (and the allied system of artistic information and criticism) is the development and orientation of artistic taste. The delivery of finished products is not a simple technical task; rather it involves creating a lively relationship between artists and the audience. Through these institutions the public's tastes and wishes are reflected back to the creative workshops and the artists themselves. This is how the relationship between the work of art and the public, and between artistic policy and creative production, is developed.

State direction of artistic life is intimately related to and inseparable from Party control. The Party's ideological control involves not merely elaborating principles of artistic policy but also the entire process of realizing these principles and making them succeed.

One of the basic tenets of our artistic policy is *democratism*: a dialectical process aimed at harmonizing central directives and decentralized executive powers. This harmony is achieved in two ways: First, state direction, in all decisions relating to the essential questions of artistic life, relies on the opinion of distinguished representatives of each artistic discipline, involves them in the preparatory work of analysis, and invites their recommendations. Second, there is a lively mutual exchange and dynamic between central and local control.

The provincial artistic forums and centers fall directly under the local town and county organs of administration, but the will of the state prevails there, too. This system of double supervision ensures that decentraliza-

tion in cultural and artistic life renders central control not merely formal but, on the contrary, truly effective. The central leadership keeps the local administration and the heads of the creative workshops informed about general and specific objectives of national artistic policy and about its observations concerning the local area; it regularly evaluates the activities of each workshop, draws the workshop's attention to possible deficiencies, and reinforces positive efforts and initiatives. The productive two-way relationship positively influences both practical and ideological control.

The Ministry of Culture is ultimately responsible for the centralized direction of the artistic life of the state. Individual artistic disciplines fall within the ministry's sphere of activity. Besides ideological guidance, its main tasks are: to guarantee the material, objective, and personal conditions of artistic creative work; to strengthen the relationship between the arts and their audiences; to guide the general artistic life of the public; and to utilize material incentives in the execution of artistic/political objectives. Appointing and supervising the leaders of artistic life and organizing management are tasks for this central administrative body, which is aided in part by its own bureaucratic apparatus (called departments). The Ministry of Culture, however, operates primarily through the system of artistic associations, which are themselves under the guidance of local councils.

The artistic associations, organized like unions, are intended to secure undisturbed creative work that is socially effective, to ensure the healthy development of artistic life, and to provide solutions to artists' problems. Today about three thousand Hungarian artists are

grouped into seven associations. These artistic associations are voluntary, democratic social forums whose task is primarily to keep the topical, ideological, and aesthetic questions of artistic creative work on the agenda. The associations help to strengthen the relationship between artists and the public; they enable artists to participate actively in various public forums; they search for the most effective methods of propagating artistic achievements. They also supervise the awarding of state subsidies, maintain international relations, delegate members to the various cultural institutions, and recommend artists for awards.

The state makes available substantial financial resources to support creative work through several institutions designed to facilitate such aid. The most important of these is the Artists' Foundation (Muveszeti Alap), whose members can receive long-term, interest-free loans to subsidize their artistic work, scholarships or financial assistance for their studies, and access to the Foundation's country retreats and studios. In addition they may receive pensions, income supplements, and other occasional allowances.

The state also gives substantial financial support to artists through the creative workshops and local institutions. Moral acknowledgment and incentives play an equal part alongside financial support. For example, the activities and achievements of prominent artists are rewarded with prestigious prizes. Both the Kossuth Prize and the State Prize are given once every three years, the first prize is more than three times the average annual wage in Hungary. Artists prominent in the development of socialist culture are given annual prizes, such as the

A Chapter in the Style of the Establishment

Eminent Artist of the Hungarian People's Republic and the Artist of Merit of the Hungarian People's Republic. In each artistic discipline, eight to twelve prizes are awarded annually as well.

The state also acts as patron of the arts. Artists (mainly painters and sculptors) are assisted by the state or its institutions with the help of state commissions and competitions, which also encourage artists to create socialist works of art. The state pays special attention to young artists at the beginning of their careers, who are assisted in finding accommodations and studios and are supported by various scholarships.

As they build socialism, our people receive more and more works of art. The socialist cultural revolution helps the masses to become acquainted with and to appropriate real values. This is the main goal of socialist artistic policy: to bring about—with the help of the arts—the creation of the new, well-rounded, harmonious personality, the Socialist Man.

7
THE CULTURE
OF CENSORSHIP

SOCIALISM is a superior society. This is no empty slogan. Artists know what it means.

In the bad old days of capitalism there might have been some people who needed art. But each day brought new uncertainty: Will art survive today? Its existence depended on there being men to create it and pay for it. The economy managed to get along without art. The establishment was not committed to it and only shopped for it now and then. However high art's prestige may have been, it was based on the fact that art was not a necessity but a luxury. The anthropological certainty that art is intrinsic to man did not permeate the social institutions. Art was a commodity among others. Its survival was dependent on the whims of wealthy individuals. An extended plunge in oil prices could postpone the tribute paid to Beauty.

Socialism needs the arts. The state apparatus, the economy, and those in power need the arts. The socialist state has promised to attend to all basic human needs in order to ensure the loyalty of the society it governs. If, under

capitalism, art is a kind of costly adornment, under socialism art is an essential garment.

This is marvelous! Some express regrets, of course. They say that not just *any* kind of art is needed, but only that which will reinforce social integration. But these critics are short-sighted. They do not understand the nature of the change that in this part of the world is officially called the "liberation of art." They see only the blind anti-artistic nature of this missionary ideology and thus cannot apprehend artists' undeniable attraction to it. And yet, this profound development in the aesthetics of totalitarian socialism is quite similar to the spirit of corporate capitalism, which is rooted, like the critics' concept of freedom, in the free market. All that they criticize can also be found in its purest form in the capitalist enterprise: if it is large enough, it is already a prefiguration of state socialism.

The Corporation Artist

Outside the capitalist corporation's walls there is still an ideal free market where total freedom of opinion and speech, the right of assembly, and the freedom to organize flourish. Everyone goes his own way and can become a proud and independent artist, free of censorship. But inside the company it is a different story. There, the employee must reckon with a microcosm of socialism. His human rights are severely circumscribed—except, of course, his right to work. He cannot go outside the walls,

cannot wander at will around the factory, cannot say, write, or organize whatever he wants. In these matters it is the firm's interests, conveyed by its owners and managers, that determine right and wrong within the corporate culture. The employee may love his work, but he cannot do whatever he likes *unless* his ideas have first been approved by his superiors. His skills have no value in themselves; they exist to sustain the fiscal health of the corporation. His relations with other members of the company are not strictly private; they are defined by the hierarchy of professional skills. If he does not live for his work, the company will let him go. As long as there are other corporations for whom he can work, he is all right, even if he is fired. He could even, if he wishes, leave of his own accord!

How is this (admittedly simplified) state of affairs different from state socialism? Only one aspect is truly different: the existence of other companies. Under socialism it is the same giant firm everywhere.

Suppose that the company for which you work buys and sells art. The board of directors, faithful to the owner's wishes, seeks free and independent art. Anyone can come in from the street. If his art is marketable, the whole company will work for him; no one will intervene in his business. If his artistic freedom is curtailed, he can threaten to leave the company and look for another, or he can choose to become self-employed.

Now consider the free artist who is asked by the company to paint the portrait of the owner, or to create a sculpture that symbolizes the company's ideals, or simply to say something nice about the firm on television. The business part of the transaction is over. The money

he is paid is not a part of profits; it is remuneration for having complied with the ideas of the firm's management. Creative freedom has undergone a subtle change: the more successfully the artist has identified himself and his ideas with the interests of management, the more creative freedom he can retain. He has become a *directed artist*. He has become a company artist.

How is this state of affairs different from socialism? Only to the extent that, under capitalism, the artist is free to resign and go to another company. In our part of the world artists can only find employment with the artistic department of the national company or with one of its branches. All artists are the firm's employees, and their colleagues (the other employees in other departments and branches) are their audience.

The distinction between directed and free artists, between directed and free art, disappears at a stroke. The artists' existential uncertainty is over. A steady paycheck is assured. The rent will be paid, food on the table, and a roof overhead. But artists' creative freedom is also over. Nevertheless they have gained a great deal: by becoming state employees they are given special attention. Their position is not competitive but hierarchical: they gain a measure of control over the consumers of their art in exchange for being controlled themselves by the coordinating authority of the state. The company's neutrality in the thorny questions of aesthetics is over.

The ethics of state socialism resemble the ethics of a large company. Its discipline and freedom are like those of the company's workers. Further, if you will imagine the greatest possible "industrial democracy" that such a concern might achieve within the constraints of its cor-

porate culture, you will have arrived at an almost exact model of freedom in today's modern centralized socialist society.

Is it censorship that guarantees that the employees of Twentieth Century Fox will create movies that serve the interests of the entire company? Do relationships within the film studio require censoring? Is the unavoidable process of creative compromise and self-correction properly to be called censorship? Voluntary discipline, identification, and devotion are essential elements in the professional's acceptance of the company as his own. Is this not freedom? After all, didn't someone once observe that freedom is simply the recognition of necessity?

It does not matter whether the answer is yes or no: we know what this is all about. This form of censorship is far more effective than a negative, externally imposed restriction of private freedom. It is quite irresistible when it bathes the employees of the socialist supermonopoly—the nation—in its amniotic warmth. Don't forget: under socialism, there are no longer any owners.

The Fiction of Two Cultures

Society is the state's property. Art is the product of society. That part of Marxist tradition which emphasizes art's social aspects and political enthusiasms has led to the nationalization of art. Every artist is a state employee. All art is directed art. The economy has reached the peak of the development of monopolism in one he-

roic leap. Under socialism, the state is sole owner of aggregate capital and sole employer of the total workforce. It is also the guardian of knowledge and the supervisor of sensibility.

We can only escape from this condition by becoming economically independent of the state. We are even urged to do so by high state officials. In a speech delivered in December 1983, György Aczél, the Party's consummate cultural apparatchik, told the delegates to the National Convention on Cultural Policy: "Experiments that are not of common concern and not promising artistically, that do not enrich culture, should be carried out at private expense!" But our budgetary dreams exaggerate the sources of outside funding. It is true that we could try to earn our living by activities other than cultured ones, in the hope of occupying our free time "in doing what we like." But to reach the general public we must have the support of the cultural institutions of the state. There is no space for nondirected culture.

I sometimes find myself wishing for the return of old-fashioned, straightforward censorship. Its reappearance would at least be evidence that artists could remain autonomous and follow their own path. But all the magazines, all the movie studios, all the theaters, all the exhibition halls are the property of the state, and artists can draw their paycheck only from state funds. For most artists, their production is bound up with the glory and influence that ensures their loyalty, their sense of social responsibility, and their corporate pride.

Those who consider official culture as inspired above all by the red pencil of the censor implicitly assume the existence of two cultures. There is the secret culture of

the creators, who, conforming to the "eternal nature" of art and the artist, produce audacious works. This fiction embodies the concept of artistic "truth" or "authenticity," free by definition. In this view, there is always a kernel of freedom at the heart of culture.

This innocent culture is juxtaposed to the tyranny of a state socialism that violates artists and deforms their work in order to concoct a docile culture of its own. According to this view, free art is turned into directed art by censorship, and the two are continually at war.

Both views are deceptively optimistic. Traditional censorship is a useless hypothesis when applied to artists in contemporary socialist societies. Painful as it is, we must accept that our culture is produced voluntarily. Anyone has the right, of course, to label as censorship this process of adjustment by which artists acknowledge their consent. To be sure, there is occasional heavy-handed censorship—although, for whatever reason, the number of unpublished novels is negligible. And it is very rare that our work is permitted to be published solely because of such intervention. The representatives of the state would be unable, of course, to transform our contributions into signs of support if we did not wish the state to do so.

When I look for an analogy to describe this more subtle and sophisticated censorship (the process of compromise and self-adjustment that usually takes place within the framework of creative workshops), what comes to mind is a newspaper whose editors express the *collective* opinion of the paper. An editorial board of this kind can ask even the best-known columnist to make corrections: this is thought to be quite natural. The same process of

compromise takes place in a culture where the artist must speak for the whole of society. Who oppresses the writers of *L'Humanité?* The civilization whose predecessors read *L'Humanité* does not recognize the existence of two cultures.

Censorship as Freedom

We are tied to a society of progress and necessity by bonds that are stronger than fear. I am one of those who is privileged to articulate my thoughts publicly. Other than the Party politician, I am the only individual who can freely remark upon life's complexities and freely use the accepted principles of discourse. What is more, I can be subjective; after all, I am a member of an artistic community that is supposed to express permitted subjective preoccupations. Naturally I come up against restraints. But I am too deeply involved for my position to be explained simply in terms of the barbed wire that surrounds me. I am not a silent inmate of the Gulag.

Why do I not test the limits? Because I am not being forced into a corner. Prohibition plays a different role in a centralized society than in a pluralistic one. No use searching here for a general, amorphous permissiveness that prohibition would diminish. Quite the contrary: here prohibition does not diminish but creates freedom. It provides a standardized satisfaction for the instincts that demand alternatives. In the case of the artist, the choice is between spoken or silent consent, between a

fulfilled life and mere existence, between the artists' retreat and the labor camp.

I am not being cynical. The choice available to me is not between honest and lying art, not even between good and bad art, but between art and non-art. The privileges that go with my profession play only as much part in my choices as the gun license does in the vocation of the professional soldier. Art is more important to me than upholding the myth of art's autonomy. In this respect I am not a victim but a true child of my generation. I am the natural successor of those scientists who knew, even before the advent of state socialism, the pleasures of privilege, security, and influence that come with being part of an organization.

Besides, there has never been an empire so tyrannical as to obliterate the taste of creativity from art altogether. State socialism hasn't been able to obliterate this relative freedom either; it has only proved again that this relative freedom is enough for the existence of art. Creativity at any cost is our slogan, even if it serves the five-year plan.

Those, including artists, who transformed society into a single corporation believed for a while that only military discipline could guarantee loyalty. But progress and time brought the natural solution: the discipline of the employee.

I am thinking of the inner need to cooperate voluntarily. This desire impels employees of large organizations without their knowing it. The more irreplaceable the employee, and the more people are affected by his decisions or ideas, the more enthusiastically will he identify with the aims of the organization. This is because, quite rightly, he hopes to influence these goals. If he is to enjoy

the freedom to affect these aims, he must respect the rules of the game. Under socialism the gigantic corporation called the state has no competitors. Here an employee's resignation means farewell to his vocation, his only freedom.

Censorship as Irritation

The more natural we find our assimilation, the more difficult it is for us to resent the "petty censorship" we often encounter in the course of our work. After all, the artist who represents the *whole* of society must expect society to keep a check on him. In each phase of the creative process, we know that we produce only components and that the work of art can be inserted into the general culture only after it has been assembled and approved by the state. Quality control is always important, and defective parts should never be offered to the public. The cooperation of conscientious workers and vigilant management ensures the health of the overall enterprise.

Although it is natural that the part, and the individual, will need adjustment, this process can give rise to tension. The artist's pride may be wounded when employees less creative than he supervise him on society's behalf. After de-Stalinization, artists, like other professionals in the economy, demanded a new system of cooperation, and greater responsibility. This did not mean that the final message of our works of art would cease to

be that of service and acceptance of state socialism. We do not deny the political experts' right to maintain the machinery of the nationalized economy and directed culture. But they do have to learn from the failure of primitive totalitarianism. They must allow the new bureaucratic middle class, which is a product of nationalization, to realize its own potential.

Where the political leadership has not been too frightened to satisfy this demand (it was terrified, for example, of the chaos following the crises of leadership in Hungary and Poland in 1956), intervention by the state has become less severe. Instead of daily directives issued from on high, there are guidelines worked out by teams, with the participation of leading artists. Partnership displaces dictatorship. Enfranchisement ameliorates estrangement. Artists are now in the majority on the boards of directors in the institutes of fine arts, film, and theater. Distinguished writers are appointed as directors of literary journals and publishing houses; they are expected to run them, like proprietors, with a strong hand.

A new social compact has been struck. The brutal state terrorism of the past is outmoded. The new consensus satisfies the needs of the responsible professional: it makes the state's interventions merely symbolic. Sticks are exchanged for carrots. This also suits the interests of the state since it does not dilute the extent of control and does not isolate the producers of culture. Incompetence, irresponsibility, or corruption can lead to intervention, just as with the shareholders of a large company.

In a few arenas (film production and publishing, for example) the creative workshops are actually compelled

to have some economic independence. Paradoxically, the old-fashioned defacto censorship of the market becomes one of the devices for the state control of art, and it is now irresistible because the creative institutions are now monopolies, and the artists are employees.

This leads to the maturation of supervisory censorship, which becomes more like the greater part of censorship, the intricate web of our circumstances and individual bias. The process of reaching final agreement grows more refined, rooted in the nature of our work and shaped not by religious dogma but by secular ethics. There is about as much stress as at an entrance examination for college, as much irritation as for an employee when he falls afoul of his company's established taste and limitless conformity. Hurry up, be convincing! Our bosses are neither evil nor stupid: whatever is best for the company will eventually prevail.

If the politicians are not brave enough to promote the dignitaries of the artistic community into advisers, there will be continual trouble. The new generation will get frustrated if their hopes are thwarted by Stalinist methods. Of course, even limited external intervention is too much like negative, classical censorship, largely because it makes the artist acutely aware of his own self-censorship. Why not let the relationship between supplier and retailer become a genial partnership? The minor ideologies of discontent in the artistic community could rekindle a species of liberal discontent, but, of course, in the state-socialist manner: in the name of a division of labor based on expertise.

This "struggle" is like an argument between an old-

fashioned prison warden and a humane social reformer
with a well-developed aesthetic sense. The latter wishes
to replace the rusty iron chains with designer shackles.
The warden fails to understand. The reformer becomes
so vexed that he declares that jailers should not meddle
in the business of handcuff production, as clearly every-
one prefers stainless steel: it is better and more pleasing
to look at.

"I know my job best." This is the typical grumbling
of socialism's professionals. They form a permanent,
stubborn lobby against the less sophisticated guardians
of state unity, although without having to renounce this
task. Why would this process of sanctioned, if occasion-
ally prickly, "opposition" be alien to the artist, this most
sensitive soul among organized professionals?

I am a spokesman for this lobby, which makes the
directed culture of the new civilization of totalitarian
socialism ever more "colorful" and writers more "inde-
pendent." I will try hard not to forget about this seduc-
tively real "progress" that is the basis of hope for so
many. But neither can I forget that my inability to re-
sist the state is due to our distance from the previous
civilization. While the context of my irritation is noth-
ing other than my effort to be included, my threats of
breaking away are empty ones, and the success of my
blackmail would in fact be my defeat. Ultimately, I
would have to make an impossible decision: I would
have to realize my own nonexistent autonomy. I would
then fall afoul of my civilization's economic, legal, po-
litical, and moral order, and having renounced security,
prosperity, and respect, I would still have no place in
it. Such an end would not justify the means.

Progressive Censorship

Autonomy is a self-annihilating idea, like a bonfire on the moon. From the West it seems as though only violence prevents autonomous cultural activity in the East, only the brave will have the courage not to conform or submit. There are few brave men and women, but the decrease in repression is thought to lead gradually to a braver culture.

This is the optimism of the tourist. His host, the writer, reveals to him that what he can publish *today* would not have been published *yesterday*. The tourist views this remarkable progress as encouraging. It is indeed very good to be alive and write things my father could not have written. But there is nothing to indicate that we can now also rid ourselves of the corporate and bureaucratic monopoly that is state socialism. It is not like a garment but more like our skin: it grows with us. It is not our psychic distance from the state but, on the contrary, our familiarity with centrally organized life that has increased. When the state reduced the number of prohibitions, it did not cut our bonds, it only removed pesky obstacles to our self-respect. It renounced terror's whip but still managed rather adroitly to keep the herd together. Our cooperation was made simultaneously voluntary and involuntary.

For today, as in the age of Stalinist terror, we decide whether to remain writers by our choice of words—even if the choices may be different. The intellectual choice is also an existential one, and this is the key to maturity in

employees. There are only writers and nonwriters, not a variety of writers. Editorial boards select them by examining their decisions. The work of art is a most appropriate basis for judgment.

The professional writer knows that the right to speak carries with it responsibility. His writing must be not only beautiful but also useful: his care with these two aspects is what makes him a writer. It would be a mistake to think that this care is simply a sign of self-restraint. I have to shoulder the concerns of a company the size of a nation; I must learn to give it my complete attention; I must grow into my role. There must be civilizations that are more tolerant toward their artists, but what could be more peaceable than the demand of a state apparatus for expertise and maturity from its privileged professionals?

No one writes my books, paints my pictures, or makes my films for me; I dictate the speed, and the cultural apparatus is at my disposal, awaiting my suggestions. It does not requisition. I do not have to meet a given quota, or work to a deadline. My work permit stipulates only one condition: my work must have an application in state culture.

Long gone are the days when artists waited, in happy or frightened ignorance, for successive instructions concerning speedy fulfillment of the five-year plan! Today every artist is a minor politician of culture. We prepare our innovations so as to bid competitively for the creation of an official aesthetic. In our eyes the state represents not a monolithic body of rules but rather a live network of lobbies. We play with it, we know how to use

it, and we have allies and enemies at the controls. Today "censorship" works through this calculating and accommodating spirit rather than through any sense of defenselessness. Where the state is charitable, artists will try hard not to give offense. Generosity from on high will be matched by docility from below.

"I don't really understand why it has not been published when it really could be," we say, even to the boss's face, when we come across *unnecessary* restrictions. We are annoyed, even publicly, when the experts in control are not up to their job. We anticipate the next guideline (which we hope to shape ourselves), and this is not just wishful thinking. Today the consensus of state socialism is built out of the compromise of professionals, critics, planners, and artists.

Progressive censorship does not demand from us a vision of the perfect society, or even evidence of ideological fealty, but rather proof of sincere participation. Its chief wish is that social unity be preserved. Its tolerance, although not unlimited, is considerable. Its scope is determined not by autocratic fiat but by the flexibility of minds that are willing to cooperate. Its slogan is: "He who is not against us is with us." It is like an empty sack that artists with a secure existence fill with anything that will not burst it.

The tourist does not understand that the relaxing of regulations may deepen assimilation. Progressive censorship is simply the self-restraint of company artists.

The New Basis of Socialist Civilization

It seems that everywhere the trend is toward this "progressive censorship," even though sometimes there are glimmerings of dissent and echoes of repression.

Although the state has not given up its right to make decisions, the separate organization of censorship is beginning to decay as it is slowly absorbed in the great art factory, in the midst of negotiations about investment and the battles for status among workshop leaders, arts lecturers, critics, and film distributors. Censorship becomes culture itself.

Today we do not work in two departments, labeled "creation" and "censorship." "Medium" and "message" are united by one and the same inspiration. Talent is a divine gift again, the mystery of creation is once again left undisturbed. We are like the gardener who sows quality-controlled seeds on allocated soil and is then filled with wonder at the miracle of creation. All culture lives by its ability to reproduce itself. We would have to be outsiders to see the parentheses of this culture as a prison.

The freedom of capitalist culture was based on the consensus that considered the need to produce for the market an unavoidable, almost uncontrovertible premise. The artist could express hatred, even toward this constraint, as long as his work was marketable.

Here, in our part of the world, state finance and control play the same role that market constraints do within capitalism. It is a restraining and stimulating basis for

our civilization, firm and inviolable. The socialist artist, too, is exposed to economic forces, which in his case are generated by the state. Here permission replaces purchase. Art, by its very existence, can only affirm the system—whether capitalist or socialist—that guarantees its survival.

Both cultures rest on a consensus shaped by coercion. But the content of the consensus is different. The fact is that planning, unlike the market, is not a placid sacred cow. It cannot tolerate contempt. But it gives permission more and more readily to criticism and differing opinions as long as they do not challenge the prerogative of planning and the artist's status as employee. Other privileges compensate for the lost autonomy that went with the independence of the market, allowing artists to cut the ground out from under their own feet.

"Yesterday's freedom is different from today's," the politician of socialist culture sighs with satisfaction. "Freedom does not transfer from civilization to civilization. It cannot dictate values. In each civilization freedom is reborn in a new shape, and only those unfortunates who are disturbed by the transition will imagine that there are better and worse civilizations; there are only winners and losers."

8

ART AND
THE ECONOMY

UNDER SOCIALISM art is an uneconomic liberation, for the support of culture requires considerable unprofitable expenditure. Nonetheless, the state considers this expense a necessary item in the national budget. Society is given art as a natural part of its wages; culture is part of an infrastructure that organizes free time at a nominal price. Only one thing is expected in return: art must remain loyal.

The least art owes to its supporters—to the economy and to the state—is to educate the people in a constructive spirit for their roles as obedient workers and dutiful citizens. In the period after the socialist takeover this pedagogical goal was thought to consist solely of overt political agitation. Although the tradition of "productive, revolutionary, and national themes" survived into the post-Stalinist era, it was discovered that aesthetic regulation alone would do the trick.

Does it pay to invest enormous (and scarce) resources in the production of art? There is no need here for the

precise answers of an accountant. We shall run out of food before we run out of art. Thanks to our socialist state, society does not measure its gift to the arts any more than bees weigh the honey they make. If an economist calculated the extent of this uneconomical expenditure, he would be shocked to encounter the pride with which the majority of the intelligentsia—including the artistic community—accepts responsibility for this fiscal fiasco. The relationship between art's inherently uneconomical nature and its "liberation" under socialism is self-evident. Socialism's intellectual life offers protection to a long list of uneconomical enterprises—enterprises that under capitalism would compete for the unpredictable handouts of wealthy patrons. That such enterprises flourish under socialism is evidence of the superiority that the organized intelligentsia attributes to state planning. The capriciousness of capitalism is replaced by the security of socialism. Every uneconomical enterprise is one that has been liberated from the fetters of capital.

This list is full of strange extremes. Many are inclined to consider the fantastic events of the Chinese Cultural Revolution to be a symptom of backwardness. For two years industrial production in China was halted for the sake of creating and organizing an intellectual attitude. Or take the example of one of our century's more effective organizational achievements—Pol Pot's Cambodia. Radical state planners murdered millions in order to abolish the economy itself and thus create a *tabula rasa* for the new culture.

But the more advanced socialist countries are not immune from this type of impulse; indeed, they are per-

meated with acts of uneconomical liberation. For example, the planned administration of all labor is an expensive way to eliminate the tensions rooted in unemployment. The nationalization of education, information, public taste, science, and art makes all these institutions of creativity uneconomical so as to save them from unworthy profiteering.

Uneconomic liberation incorporates and elevates creativity. Initially it gives short shrift to the intellectual richness that was created, almost incidentally, by the culture of profit. But this is the inevitable price if creative work is to become the apex of social activity. As representatives of the state, artists are near-controllers of the collective imagination. For generations to come it will remain in their interest to preserve the prestige of the state's monopoly on culture.

Uneconomic liberation is not, of course, a liberation of the private individual. Socialism offers security and power in return for the loss of private freedoms. In the new society, the highly educated intellectual—the artist, for example—is furthest away from the ideal of the private individual. It is the manual worker—the least educated employee with the least responsibility—who is nearest this old-fashioned ideal. The new restrictions grant him nothing but security, a far cry from the power that uneconomic liberation offers to the culture professionals.

The Artist as the Opponent
of Economic Pragmatism

Whether or not art flourishes depends on two factors: first, the number of institutions established by the state and the extent of the state's generosity; and second, the extent of cultural "consumption" planned for local administration and its factories and for the individual. These national targets must not be exceeded, nor must there be any shortfall. Commissions for work must be distributed and the artistic product paid for.

But art may suddenly seem to be a financial burden, mere propaganda financed by taxpayers' money, if this neat formula is contaminated by elements of the market economy. Our artists are not at all enthusiastic about the relatively recent idea of making some cultural enterprises pay for themselves, on the model of independent companies using financial incentives.

Yet this is what is happening. The state is seeking to reform and decentralize some of the more unwieldy and inefficient aspects of the economy—including the culture industry. Directed consumption and the appearance of surplus income demand their own culture, as is most obvious in entertainment, the art form most dependent on a mass audience (record production, show business, and the thriller acquire socialist forms).

Of course, allowing relatively neutral artistic sectors to become independent of the state's centralization or making them profit-oriented branches of industry does

not restore artistic freedom. The needs of the audience—and aesthetic and political taboos—must be met in this new branch of industry, and this goal is possible because of the audience's assimilation.

However limited the introduction of the principle of profitability may be, this change has provoked resistance among many artists, especially those committed to "high culture"—critics and professors. It is not as though fine arts have been officially abandoned in order to patronize more vulgar audiences. It is just that in the profit-making branches of art the artist is not considered a "historical curator" of the nation's cultural heritage, as he is when he labors in the garden of "serious" art. And audiences are discovered not to need any noble message. Nor do they wish to pay for it.

Some artists are simply unable to tolerate the renaissance of the vulgar masses, whose love of popular culture—those forms of artistic production most likely to turn a profit—has been encouraged by the directors of culture. This predicament has brought about a strange, neo-Stalinist revolt. The "enlightened" cultural czars have now to reckon with a progovernment, hard-line "opposition" that demands a more rigorous centralization.

Thus art's "main guidelines" have been reinforced. It is declared that the profits derived from the production of commercial culture will be used to subsidize serious art—as if the state had different funds for different purposes.

The fact that serious artistic products can be purchased cheaply remains the symbol of their cultural su-

periority. Profitable art forms must both pay for themselves and pay a special tax. The withdrawal of state subsidies and the special tax are justified on the basis of a particularly stigmatizing argument, i.e., that popular mass culture is not "valuable" or "educational" enough to warrant state support. By the same token, commercial theater and cinema are permitted, but if too successful, they are penalized. Most people, however, are clearly quite happy to accept the mounting cost of paying for the entertainment industry. Excessively "solipsistic" or "destructive" entertainments are still, of course, out of the question.

During the Hungarian economic reforms the most heated debates were provoked by artists who feared that decentralization and the introduction of financial criteria might create a new, less manageable cultural milieu. The entire arsenal of the anticapitalist critique of culture was deployed against the innocents in charge of the reform. Entire films were made and literary papers written criticizing private interests, materialism, and irresponsibility in the public cause. Artists voiced unanimous protest that art, liberated by socialism, should not once again become a commodity. And they were right to link the loosening of ties with the minor decreases in their prestige that resulted from the effort to make some artistic institutions more profitable. After all, who will look after the country's most precious legacy if its most unselfish, most valuable cultural servants are no longer appreciated or honored?

The political leaders must have noted with inner satisfaction that the fear of culture's severance from the

state did much to blunt anticensorship attitudes. Serious (and unprofitable) art acquired a new aura. The supportive state was now perceived as the protector of aesthetic innovations, the opponent of a degraded (although profitable) mass culture; censorship was embraced as the guarantor of stable values and of a constructive humanism.

The Cultural Limits of Economic Pragmatism

After politicians, artists are the most determined enemies of secularization, pragmatism, and relativism— everything, that is, that the dissemination of a competitive spirit and the profit motive would bring about. But it would be a mistake to imagine on the one hand a whole society hungering for a return to the profit principle and, on the other hand, an official culture standing in lonely opposition to it. There are limits to the desire for decentralization in every social grouping and on every level of society.

The tendency toward pragmatism (with its consequent, although not inevitable, moderation of ideology) is the result of economic pressure. But in the nationalized society of socialism this pressure is, to some extent, superficial in all the professions. Socialist society has never been driven by economics alone, even during its periods of industrialization.

True, to some extent everyone respects common

sense. Not even artists relish meetings with workers, organized by the factory's Party committee, where they will be greeted by a hungry, terrified audience. At the same time, for every responsible employee, the greater his responsibility, the greater his opposition to the profit principle. We work hard to maintain the kind of industrial society in which there is nothing to be industrious about. The capitalist rat race is over; there is nowhere to rush. The rate of work has visibly decreased. The public is both annoyed by and ambiguously proud of this fact. It is as much a cultural as an economic phenomenon. Even the working class would have reason to worry if the state's grip were weakened.

The battle for economic efficiency is sometimes quite fierce, but this struggle is not simply between orthodox socialist hard-liners and more moderate economic pragmatists. Both are members of a technocracy that is in no way an enemy of nationalization, or the planned economy, or directed systems of information; they are, indeed, its creations. The first sign of the dilution of centralized power was enough to convince the economic pragmatists that their reforms must not challenge the monopoly of the state. They quickly recognized the higher interests of state power, just as artists concede the requirements of political aesthetics.

State socialism is unwilling to permit industrial man to become a predominantly economic being again, independent of the forces that still make him a puppet of the collective institutions of art, politics, sport, family planning, education, and defense. That is too high a price to pay for economic progress. Higher productivity by

means of financial incentives would make it impossible for the bosses to retain their cultural and political domination over the workers—domination that is particularly vital to peace in the workplace. The lower rate of work is undoubtedly less profitable to the overall economy, but in return the worker offers the state a high degree of control over his personality.

Neither group—one supporting financial incentives, the other backing moral exhortation—should be seen as rigidly dogmatic. There is continual migration between them. Their struggle is within the law and is loyal to power. As a result, waves of decentralization and recentralization follow one upon another throughout society. These two groups fight with each other not because one is an expert in economics while the other is infatuated with ideology and not interested in filthy lucre. The adherent of moral motivation protects the sway of the state over the economy and thereby guards the power of all professional planners. It is for the sake of this continued hegemony that socialism has to renounce maximum economic efficiency, not just in the short term but for all time.

If the economy were allowed to follow its original impulse—efficiency at any cost—the people would again have to concede a division between the economic and political realms. While the economy's professionals might gain a measure of independence, they would lose those qualities of holiness that had marked them out as the spiritual champions of aggregate capital who had "triumphed" over the harsh domination of money. And one would witness a disruption of the sacrosanct integration at the center of state power that invented (or

forged) a group of employees whose leaders were both the nation's economic representatives and natural spiritual guides. The economic professionals can only be assured of this advantage by constantly subordinating their own power and by acknowledging the supremacy of the state.

The cultural professional and the artist perhaps know more about this necessity than does the business executive. But both ideologues of moral incentives and business executives devoted to pragmatism understand this "intellectually." It would be more accurate to say that there is a battle going on inside each of them, between the economic liberalizer and the political dogmatist, the ignoramus and the social planner, the exploiter and the redistributor.

Nor should it be forgotten that the ideologue of the working-class movement, the supporter of moral incentives, does also, to some extent, represent the genuine feelings of the working class. This explains the surprising fact that often even sensible workers experience this policy as their own, sometimes even when it has been at the expense of their paycheck. It would be a great mistake to think that they are merely victims of propaganda and coercion when they consider the guardian of social integration—the Party—as their good friend, almost a benevolent monarch, or at least the lesser evil compared with their slavedriver bosses. The working class does not relish class struggle.

Class struggle has returned to the role it had in the precapitalist economics of assimilation. It only breaks out when and if financial survival, and the stability and self-confidence of socialist assimilation, are endangered.

Economic pragmatism provokes class struggle and thus can never be fully adopted by the fathers of a planned society.

The Artist as Owner

Marxists, when they wish to understand people's consciousness, always seek to define their "material existence" and "economic base." For artists, under socialism, their consciousness has everything to do with the "uneconomic" and "liberating" function of the state monopoly. We service an unprofitable branch of industry within a large corporation which has freed us from the struggle for existence. Its executives have secured prosperity and social recognition for us and a role as its exclusive spokesmen. Nothing—certainly not our own position—prevents us from seeing this arrangement as synonymous with the common good.

Our gifts and commissions are lavish, but they are in proportion to the effect artistic production has on the general public. These same investments guarantee our growing influence. There is no need for violence: we are eager to help the state infuse a helpless society with culture. Every artist is also a political, economic, and cultural functionary. Our responsibilities are the same as those of the other members of the elite. We all have stock in the same company.

Society is like a compressed sponge, filling up with liquid whenever the pressure eases. I am a drop in this liquid. But I am not a victim. I am a leading professional.

Art and the Economy

As an artist, I work at the center of the cultural appara-
tus, whose sphere of authority, like that of the banks, the
police, or the sports authorities, blankets the whole of
society. Whether I like it or not (so I may as well like it),
I help direct the distribution of knowledge. My involve-
ment with those in power is a proud symbol of our
mutual rule, which I ennoble by decorating the walls of
the company's boardroom. As payment, they confer no-
bility on me by granting me a seat at the table.

One does not abuse such trust easily or lightly. Cultu-
ral centers are built next to factories. These are meeting
places where liberated culture can ascertain its useful-
ness, and where pacified workers can replenish them-
selves with idealized images of their own life. The social-
ist state—thanks to its pliant intellectuals—is no longer
worried that its workers will have plenty of spare time
for hostility, radio broadcasts that provoke discontent,
cities packed with controversial posters, newspapers that
distort the truth, subcultures that oppose efficiency, and
churches that encourage spiritual transcendence. It
knows that it will receive invaluable help from its co-
owners—the intellectuals. It is confident that, thanks to
an all-embracing cultural network, the workers will in-
tensify production, not just without complaint, but with
enthusiasm. In return, the state will ensure that the
worker's whole personality is involved. He must prom-
ise to visit museums, to read or at least discuss a few
books, or see one or two films, to remain friends with his
coworkers even after working hours, and to take part in
political education. Is this too much to ask?

Directed art is nothing other than a service provided
by the state, a blessed and necessary regimentation, even

if overwhelming at times. The state prevents my art from becoming a commodity, and it guarantees my status as a teacher of the nation. Accepting its restrictions, I make the same "sacrifice" as does the technocrat when he creates a scholarship for me. Through censorship I become an intrinsic part of the planning establishment. What I lose is my powerless, illusory independence.

Perhaps one day artists might enjoy less direct supervision by the machinery of state, perhaps even through open negotiation with the other institutions of control. But in the meantime we educators need to be educated, too.

Today the only sign of art's *realization* is that it is censored and that the technocrats must use it as a moral incentive. Perhaps one day the censor's cuts will become burdensome, if only because they will have become superfluous. Today the dying civilization of capitalism does not hold the attraction that might make most artists choose independence and uncertainty over the unprofitable, liberated service of socialist inefficiency.

9

THE AESTHETICS
OF CENSORSHIP

THERE ARE two ideal models of the aesthetics of cen-
sorship, each capable of imposing or nurturing a viable
cultural consensus. One might be called Stalinist and
the other post-Stalinist, but as they do not necessarily
succeed each other and often coexist, it might be better
to call them "military" and "civilian," or "hard" and
"soft." In the Soviet Union, for instance, the brief
burst of artistic freedom following the Bolshevik Revo-
lution was soon eclipsed entirely by Zhdanov's rigid
dogma. Thus, a lenient and tolerant (civilian and soft)
period was superseded by a tough and brutal (military
and hard) era. After de-Stalinization, state aesthetic pol-
icy was enriched with "civilian" virtues under Khrush-
chev. In China the fluctuation has been even more spec-
tacular and dramatic. The era of the slogan, "Let a
hundred flowers bloom," was already a reaction to
what had been a harsher period, only to be followed by
the intolerant spirit of the Cultural Revolution. Up to
the present time, the yin and yang of hard and soft
policies have alternated.

Under Stalinism, the state keeps busy suppressing both its real and imagined opponents. It is consumed by paranoia and suspects everyone of potential heresy. It feels itself to be under siege. Society is militarized, ramparts are mounted, orders are issued. Artists are soldiers to be drafted in the battle to consolidate the victory of socialism. Art is deemed a kind of martial music, a clarion call accompanying troops in the trenches. Artists are to act as cheerleaders, quartermasters, flag-bearers, morale-boosters, equipped with precise battle assignments. Paintings are posters, theater is agit-prop, movies are newsreels, literature is unabashed exhortation, propaganda. Neutrality is treason; ambiguity is betrayal. These aesthetics can justly be called "military" or "hard" aesthetics.

As the socialist state grows more confident it no longer needs to use the blunderbuss of Stalinism. It can afford to relax. Overt suppression is no longer needed when conditions have stabilized and overt opposition eliminated, or terrorized into submission. Reforms are introduced, "excesses" curbed, crimes condemned. But apparent liberalization should not be mistaken for a genuine lessening of state or Party control; it occurs to the extent that citizens have accepted and become adept at their own assimilation. The state need not enforce obedience when everyone has learned to police himself.

Aesthetic policy begins to shift (often with glacial speed) from "military" or "hard" to "civilian" or "soft." Artists are permitted, within limits, to experiment once again with the *form* of their art. The boundaries of the permissible expand. Of course, art must still serve the state and strengthen socialism. But the *manner* by which

the artist may do so is largely left to the initiative of the private individual. Still, no art is permitted that refers only to itself, or to strictly private obsessions or preoccupations. Such art would be solipsistic, self-centered, self-indulgent. Art must always take pains to respect public goals. In this sense, and in this sense only, art is "privatized," while remaining subservient to the state since no one but the state can subsidize its production or distribution to the public.

In other words, the artist, a soldier armed with paintbrush or pen under Stalinism, is, after de-Stalinization, demobilized and returned to civilian life. He remains, however, very much on active duty, in the reserves, as it were, always aware that his status might change the moment war is declared.

The example of Eastern Europe shows that post-Stalinist aesthetic policies do not necessarily bring with them a slackening of control. While soft aesthetics tend to extend culture into neutral terrain (by removing it from the realm of the overtly political), soft art erodes assimilation only if the state stubbornly clings to Stalinist practices, refuses to recognize that neutrality can have a pacifying function, and fails to provide space for it through suitable regulations.

The "privatization" of art is a necessary part of the peaceful aftermath of the Stalinist campaigns of centralization, but this does not mean a resurgence of individualism. Rather, it is a sign of the permanent assimilation of the individual. The post-Stalinist artist is a model of the new individual. The state points to him to illustrate how expertise and talent must be utilized. And the poet intones: inherited gift and acquired caution are our tools.

Even where post-Stalinist art seems to evince protest, this is not in opposition to state control but is intended as criticism of Stalinist vestiges, a reaction to official nostalgia for the culture of martial law. Such art merely demands that the state recognize its own victory.

Any effort on the part of the state to spurn artists' attempts to collaborate can lead to real tension, even to the creation of cultural kamikazes—the dissident artists—although hardly any such artists are to be found in countries where the transition from Stalinism to de-Stalinization was swift and resolute. State artists feel threatened by dissidents who strive for the restoration of individualism. In the era of soft aesthetics we work hard to convince the state that it has no more enemies. The romantic individualist compromises this demand and provokes suspicion of de-Stalinization, of progress. He threatens our role as counselors who responsibly regulate and satisfy public and private aesthetic needs. He subverts our solidarity with the state.

The Hard Times Are Over

It is crystal clear to young and old: we live in the age of the corporation. The secret of our happiness is total, unconditional involvement with the firm. Our employment is fixed; we can only move if we receive a new appointment; our role is to work. Each of us in his own way has been persuaded that he has entered a binding social contract at birth. No one may be so absorbed in his

own work that he does it for its own sake. The artist who can accept this condition is allowed to entertain us. The state artist is the mystic of the corporate ethos. Even though he is nothing more than an industrious professional, he remains the possessor of the aesthetic of the common good and of corporate prestige.

Post-Stalinist art shares a similar objective with Stalinist art: to strengthen social integration. The difference is that civilian or soft aesthetics are designed not for an audience newly incorporated into the socialist state but for a populace born into it. Socialization, not conquest, is the underlying assumption of the new aesthetic.

Artists themselves are now an integral part of culture. It is not difficult for us to see ourselves as products of our own genius. On the contrary, it is quite natural. We, too, have achieved our privileged status through the educational system. Its selections and examinations test our loyalty and refine the quality of our work. Selection is based on criteria of structural principles, a sense of style, a knowledge of tradition, an awareness of reality, an appreciation of the audience, a sensitivity to social context. Politically, the post-Stalinist artist is no longer expected to declare his allegiance. His loyalty is assumed. Under Stalinism, everyone was guilty until proven innocent. Today, it is just the reverse. We are trained to become experts in social critique. We anticipate reforms, read between the lines, and criticize society as intimately as do members of the Politburo. If we seem to break with the strictures of Stalinist tradition, it is only to better effect its intentions. Still, every work of art must somehow prove that it neither opposes the primacy of state planning nor harbors plans of its own against the exist-

ing order. Only constructive neutrality is required. István Katona, a leading member of the Central Committee of Hungary's Communist Party, summed it up quite succinctly:

> [Today] the Communists show tolerance toward people who have ideas and standpoints that differ from theirs, and they try to persuade them by arguments. The characteristic features of the past thirty years are a readiness to accept things, the presumption of good intentions, and understanding—as long as no one takes action against the socialist system and its political foundations.

Public oaths are passé; quiet acquiescence will suffice.

To sum up the "task" of soft art: instead of being artists of the "vanguard," as in the embattled days of Stalinism, we must now become artists of the "silent majority." Our audience is the organized middle class, which maintains the state's economy, services, and culture, employees with an educational background similar to ours. They are professionals and intellectuals, and our future elite—the community of state planners—is selected from among them.

The planners reserve the right, of course, to support Stalinist art. But they know that the organized intelligentsia is inclined neither to fervent loyalty nor to self-isolation. The new class listens increasingly willingly to the pacified, apathetic songs of state artists. It takes its inspiration from the whispered complaints of assimilated individuals.

Soft art does not glorify the elite but domesticates it, comforts it, and contains it by making a cult of its own sincerity. We are not allowed to determine the extent of our freedom, but as long as we accept the state's general jurisdiction and coordinate our dreams with it, the state will be pleased to guarantee a slow increase in pluralism. State artists can rightly be proud of the fact that we help to disseminate a particular kind of freedom within the constraints of state culture. We build state culture with bricks of free will.

We resist individualistic sentiment in art while constantly seeking to discover the manifold ways in which the individual can be recognized for his artistic contributions. This is what is meant by "privatization of art" in post-Stalinist socialism. It is the most civilized way of pursuing the aesthetics of the common good. Consciousness replaces coercion. Consensus is shaped only by unwritten principles, voluntary prohibitions, and unconscious commitments. Under Stalinism, our plight was like that of the fish whose owner foolishly locked the aquarium in fear of its escape. Since Stalinism, the owner has become wiser and the fish happier. The aquarium remains the same.

The Prohibition of Art for Art's Sake

The most lasting and at the same time most instinctive aesthetic principle of totalitarian socialism is the prohibition of art for art's sake. This prohibition permeates all

spheres of creative work even after positive commitment to Marxism-Leninism has been dropped. It is more intrinsic to us than is fear of the police. Here I do not mean simply the rejection of that infamous artistic philosophy, *l'art pour l'art.* A work of art can, of course, be a little playful, but never just that. It must not refer to itself alone. As opposed to the aesthete-artist, the state artist is always indebted to the world. We always make sure that the work of art is not only entertaining but enlightening as well. It cannot be allowed to become a paradise with its own laws, a narcissistic escapade that questions the objectivity of "real" values. We always build a bridge that secures passage between the laws of our own inner world and the norms of the outer directed world, between private and public passions, between artistic pleasure and the common good.

But it is not only elitist and esoteric aesthetics that are considered evil by those who prohibit solipsism. State culture considers solipsistic all aspirations that are in any way autonomous, or spontaneous, or uncontrollable, or individualistic, or simply intractable. The prohibition of solipsistic art is like the prohibition of madness: it normalizes art.

Art that refers to its own medium is mere "formalism." It is solipsistic because it denies the primacy of "content." But even the "content" can be branded as solipsistic if it is not linked with one of the myths of state culture, say, "collective is beautiful," or "there is one truth only."

The formation of directed culture becomes complete when artists internalize the prohibition of solipsistic art.

This prohibition provides the fundamental backbone to the definition of art in state culture, just as the principle of autonomy did in the old one.

Now that the West recognizes that the progress of socialist state culture is irreversible, and there is peaceful cultural coexistence, the prohibition of aesthetic solipsism takes on a special significance. State artists run the risk of unknowingly being seduced by forms and themes imported from the autonomous art that flourishes outside the borders of totalitarian socialism. With détente, cultural exchange renders the frontiers between the two civilizations quite porous. The good intentions of state artists may not be sufficient to immunize them against untoward influences. Thus the state persists in prohibiting aesthetic solipsism in order to avert backsliding. Autonomous ambitions threaten to sever the private from the public; they puncture the process of social integration; they are at odds with the common good. The state therefore opposes all forms of solipsistic art.

Politically Neutral Art Is Not Solipsistic Art

The enlightened socialist state understands that politically neutral art poses no threat. On the contrary, it fosters assimilation and acquiescence. What is important is that solipsism be opposed by always allowing for the

social context of a work of art. It is sufficient that only one of the tenets of directed culture be affirmed while others are neglected by our neutrality.

For instance, if the artist accepts the official version of history in, say, his historical drama, this necessarily implies his political consent and offers sufficient proof of his embrace of the didactic aims of the theater. He can then afford to use a smattering of "novel" psychological effects or even "avant-garde experiments" as a technique of staging or presentation, and nobody will accuse him of being solipsistic. The message must remain the same; the medium can change.

In the post-Stalinist era, solipsistic art is not prohibited because the state demands that every work of art demonstrate overt political engagement. The prohibition is a prerequisite: the work of art must find a relationship with its social context. It must seek a place in directed culture. And frankly, doing so is not too difficult. As long as we do not directly criticize the bureaucracy, its attitudes, or its discourse, we are already constructive. The careful (and clever) artist himself chooses the aspect of his art that will resonate with the social context. An ostensibly ambiguous or aesthetically neutral work of art is as acceptable as one that is unabashedly progovernment. The mere possibility of constructive interpretation is enough to establish a link between the artist and the state. It then falls to the critics—those chroniclers of context—to baptize and inaugurate this linkage.

The Range of Solipsistic Art

Although there is a general prohibition on solipsistic art, the strength of the prohibition varies from one genre to another, and even from one individual work of art to another. Progress usually takes place by permitting or even encouraging some solipsistic aspects that are subordinated to the educational function of the work. Our spirit of innovation aims at just such pseudo-autonomy and, indeed, finds satisfaction in it.

Assessment of truly solipsistic aspects varies across the whole range from instrumental music to political cabaret. The regulations always vary. Post-Stalinist reform is simply the official recognition of these variations. A separate consensus is worked out for each genre, and the relevant administrative bureaucracies in the state ministries and in the Party elaborate guidelines in consultation with the artists about the special characteristics of the particular field. Cooperation can be expected only if the characteristics of the genre and even the artist's personality are taken into account.

The range of the permissible is not endless. Even at the most permissive end of the spectrum as, say, in the case of a sonata, there can be no scope for interpreting the work merely as an expression of the composer's inner musical world. Even music has to be socially relevant, constructive, and oriented to a wider public. It cannot be "antimusic"; it is, after all, public property.

Considerations of distribution create fine variations. Aesthetic experiments are more likely to be allowed

when a smaller public is involved. In state aesthetics mass art is inherently conservative; it cannot be bold or daring or revolutionary. The extent to which a genre may dip into solipsism depends entirely on the size and social composition of the probable audience. Trained sociologists issue the permits. Whenever lyrics accompany the music, for instance, the scope for acceptable solipsism narrows.

Classical genres carry an almost political authority. There are no scandals in opera. The artist there is like a museum guard who knows that he is handling national treasures.

The sensuous arts—music, dance, painting—are given a greater measure of permitted solipsism. The less sensuous the genre—novels, movies, for example—the stronger the ban on solipsism. It would be misleading to see this injunction as wholly negative. It is rather a principle like *horror vacui*. As soon as we draw on society for our material, we instinctively give way to a vague *internal* pressure. We strive not to allow ourselves to treat our material as a solipsistic language, even in music, dance, and painting. Because solipsistic art is prohibited, a whole range of genres remains "representational," rather than opting for "epistemological" adventure.

Art forms that inescapably are involved with social concepts and human lives cannot organize their aesthetic elements into an independent paradigm, severed from all external influence. Themes that have a real life outside the world of art cannot embark on an entirely independent life within it. Whatever is a part of external social organization can only have a kind of colonial indepen-

dence within the work of art. Meaning itself is at the limits of what is permitted. It may be trifled with least of all: it is far too sensitive to power. Ironists and satirists are unknown species in directed culture.

Literary Art

Socialist art is conspicuously *literary,* not just in the sense that literary forms are highly thought of, but also in that the fantasy world of nonverbal forms and genres ape the literary model. Their inspiration is didactic, their gestures can be verbalized, and their structure is linear. They have a program in all senses of the word: a theme, slogans, punchlines, and so on. Even literature itself is "literary." Fiction is anecdotal, and poems more propositional than in the West. Even in the era of television Gutenberg's galaxy dominates socialist culture. The state artist instinctively wants to be supervised. This desire pushes him to shift his chosen medium in a literary direction and makes any artistic form more propositional.

The aesthetic consensus, however far-reaching and liberal official state policy may be, remains oriented toward "content." Greater freedom of form simply means that we now have to reconcile our "stylistic method" not with the explicit demands of the state but with the implicit needs of the "content" of our work. The responsible nature of this "content" is guaranteed by the degree

of our assimilation. So we are economical with form. To keep the medium "meaningful" we minimize the distance between form and content.

The message is all-important! It is as if some sort of guilty conscience forces each artistic medium toward a common reductionist language. This is a kind of fear of original sin, of the selfishness of solipsistic art. Art's literary character is a badge of good intentions. It is also a self-evident method of satisfying the demand for "clarity." This demand is, of course, in the interests of the bureaucracy, not the audience. The art forms are replete with symbolism, allegorical action, "faultless" and "guilty" heroes and antiheroes, but not in the interest of easier popular reception. We use literary codes for the recordkeepers, who can only make sense of what is conceptually and unambiguously expressed.

This does not mean that any such records actually exist. We are at pains to create, of our own volition, works of art that readily disclose their socially correct interpretation. It is the state artist, with his deeply ingrained bureaucratic instinct, who is responsible for art's literary character.

Organic Innovation

The overall picture is conservative even after the ban on innovation has been lifted. These days art is conservative or traditionalist not in its style but in the role it gives to

innovation. The elimination of the competitive capitalist market overturned—permanently, it seems—the cult of the new. Our ethos is that of conformity, not novelty. This gives innovation a particular function: to be a reminder, a new light thrown on old images. We can now understand those old ornamental civilizations that stagnated for centuries.

An industrial society cannot, of course, eliminate innovation for long, but it can get rid of the prickly and unmanageable side of innovation—its autonomy. In a thoroughly nationalized society, innovation will only come about in internal symbiosis with the organization of power. Innovation will be permitted only when it makes society more manageable. This will happen in the economy, in systems of information, in the social sciences, in styles of living, and even in the arts.

Aesthetic innovation is not forbidden, but it must secure permission. It has to be modest and in direct continuity with previous aesthetic values. It must in no way be a radical departure.

The state does not eliminate solipsistic innovation singlehandedly. Our innovations are an organic part of state culture because we are rooted in it. We unfailingly recognize our responsibilities. Our role is not to ape the past but to improve upon it. We build new roads to the future by extending the paths already well traveled. We do not wish to find ourselves in the chaos of freedom. On the contrary: we become more and more adept at finding ways of accepting our assimilation.

Bureaucratic Classicism

Each artistic genre or art form is "represented" by a ministerial department, so that the boundaries between art forms correspond to demarcations between bureaucracies. That the state educational system also follows these distinctions contributes to the stasis of state culture. Students who wish to become artists must choose their "occupation" from one of the approved art forms. The ministerial departments elaborate their own aesthetics. Only accepted art forms are developed through innovation. New artistic trends, imported by the managers of tradition mainly from the West, are submitted for review among the existing departments. If the managers are clever, existing categories can be stretched to include almost all genres. But distinctions must at all times be maintained, even strengthened.

Thus, only in the category of operetta can there be experiments with musicals. Rock music only becomes acceptable (and thus controlled by state authorities) when it can be seen to have continuity with local musical traditions, i.e., folk and popular music. Henceforth, rock music, too, is a "task." Pop art may be promoted from an amateur pastime to a professional occupation, becoming a feature of monumental or antibourgeois militant art. Conceptual art must take pains to prove its social utility in political posters.

Transgressing genre boundaries is considered improper. The artist who is between genres or who mixes them is being provocative. *Gesamtkunst*, the attempt to

combine genres in a single work, does not pay off unless it is an officially commissioned "social design." The organizers of demonstrations and mass "celebrations," monumental artists and television artists—the organizers of social space—may draw on many genres in their work. But without political support a work of art that combines several genres has no chance: "This genre does not exist," say the sources of finance. The "objective" obstacle to such innovation is that it has no historical precedent.

Each national culture introduces control by considering some genres as relics to be preserved. Naturally, this is done in order to "safeguard tradition." Thus, if one trespasses into certain unacceptable genres, one risks being thought not only antagonistic to the common good but also downright unpatriotic.

Parasitic Innovation

After basic regulations are established, the aesthetic tradition's enlargement begins in a controlled way. It is only natural that acquisitions from other state socialist cultures have priority. In the relatively brief Stalinist periods, Soviet culture was the model, and the imitator's humility the main virtue.

Post-Stalinist reforms involving decentralization brought about changes in the relationship with Soviet culture. State cultures have developed out of their own national backgrounds and provide unique colors for the

palette of the new civilization of totalitarian socialism. The Church has been built and Providence still exists, but now we may pray in our own national languages.

So far, only the art of negation has been admitted into state culture from individualist civilization by permission of higher authorities. But the "privatization of art" brings rigid isolationism to an end because the state is more confident of its ability to assimilate what was once considered alien. Subjects that were once forbidden or condemned as "reactionary" or "bourgeois" or "imperialist" may now be considered appropriate. For example, the Individual, with his existential, psychological, and sexual aspects, is no longer a taboo topic. With the prohibition of solipsistic art as our guiding principle, the state trusts our instincts for selection and can steadily relinquish the administration of aesthetic growth. It is we who now use the state's criteria: the Other is gradually changing from "enemy" into "stranger."

We now instinctively react against the autonomous gestures of Western culture. We ourselves divide the universe of art into two groups: "aimless" versus "intelligent" art, or "blindly experimental" versus "socially valid" art. However fascinating pluralist culture may be, we are now unable to treat it as "normal." We consider its vitality barbarous, its introspection narcissistic. We consider the captives of individualism to be narrowminded and helpless, however creative they might be. We see the West's abundant supplies not as a virtue but as gold reserves it does not need.

Let us snatch them away! Like conquistadores, artists of "socially valid" art are summoned to battle. We must

give value to what is worthless. We must make use of the natural gravitation of undirected societies toward intelligent culture. Paradoxically, the West probably sees the importation of Western effects by the previously dogmatic socialist art as a sign of its own prowess and influence. But this would be true only if the imported forms were to bring their autonomous spirit with them. Unfortunately, that spirit is permanently detained at the customs gate. As in technology, so here: innovations do not aid the independence of individuals or groups. It is the integrating capacity of state culture and not authentic pluralism that conquers.

It is true, of course, that we draw on Western artistic raw materials. As state artists we would probably be unable to work in the private sphere without the imported recipes of individualism. For our civilization is not the sum of private individuals. Writer and reader are not *independent* individuals; they are merely *decentralized*. Artists do not produce for an independent public that spends its money according to taste; they still create for the state.

Our social base is too weak to induce a renaissance of autochthonous individualism. We select from the prepackaged expressions of individualism concocted in the West, and we do so from the vantage point of the state: this is our innovative method. We prune the chaotic overgrowth crowding the jungle of capitalism and carefully transplant selected cuttings to the greenhouse of socialism. As in industry, so too in art: we have no technology of our "own." Our colleges of art teach the methods of, and justification for, this aesthetic parasitism.

113

Even our art criticism is now opening up to the West. This facilitates organized innovation. This is the rebirth of innovation, at the price, of course, of eliminating the demand for originality.

With the help of the official managers of tradition, we expose ourselves to different influences. We then systematically exclude the solipsistic parts. We transform artistic methods into ones that are of general interest and we "apply" them. We regard creative independence as an empty formalism. We sterilize it, dissect it, and lift out the parts that can be fitted into the machinery of the common good.

The results are refreshing: the cacophony of well-known slogans is transformed into a jazz symphony. The Party worker, passing the new monuments, can recognize the figures of Marx and Engels only from the two different body shapes created by the Cubist artist. Kafka's insect reappears in the nightmares of the peasant who has sprayed the potato fields carelessly. The landowner portrayed *ad nauseam* as exploiter now appears as an organizer of sadistic sex orgies: inevitably, a box-office hit. Communist partisans develop a homosexual friendship but carry on the brave struggle. Our lonely hero is lured by his lover to Paris; there he realizes that the world is the same everywhere; he decides to come home and get married. In the plays staged in factories and cooperatives, time and space twist and turn like boiled spaghetti. And Rambo has met his match, too.

Why shouldn't I utilize the style of Robbe-Grillet or Andy Warhol when our police use French tear gas and our citizens are registered on American computers?

The Delayed Green Light

Capitalist culture, thanks to its obsession with novelty, is constantly adding to its junk pile. Socialist culture constructs permissible, teachable, even compulsory innovations from this passé material. But only those effects which are no longer new can be used as innovations. Socialist innovation can only utilize Western fashions that are on the decline. Their explosive impact has been assessed by the time permission is given. Critics are ready with their themes, and the ministerial departments, experienced in cultural exchange, are ready with their techniques. This is the cultural policy of the Delayed Green Light; it guarantees slow, safe progress.

As a state artist, it makes no difference that I know instantly how I would responsibly utilize the newest developments from abroad. All potential imports and innovations must be allowed to mature, to prove their worth. They have to be favored by the state, which expects them to be not only adaptable but also banal.

The Delayed Green Light does not block the road; it only prevents our being swept away by the traffic. Continuous innovation, or innovation that is built up of many elements, would be solipsistic. Even the principle of clarity would be damaged if the artistic authorities had to concentrate on more than one thing at a time when they listen to music or read poetry. Innovation, however permissible, must never diminish our role as educators of the nation.

The Principle of Clarity

This slogan was created as a protest against the aristocratic egotism of solipsism. Since the nationalization of art, its function has remained the same: to coordinate the theory of the service of the people with the practice of the service of the state. But in the meantime, its application has changed a great deal, and this lays it open to misunderstandings about the nature of progress in our part of the world.

In the past only one kind of "content" was considered unambiguous: that which gushed out from the state to the rest of society. There was only one acceptable style, too, since the state had chosen one strikingly suitable to its one-dimensional message. "The state is within us": that was the message, drummed into us time and time again. The secret of clarity then was that the content of art had to be an exact reproduction of the state's self-portrait. To some extent, all art was a kind of performing art, and the state was the real author. Reading, watching, or listening to art was not supposed to be hard work, since the message had to be absorbed quickly. It had to be homogeneous and immediate, like electricity; all you needed to do was to plug yourself in and the invigorating current of state socialism would start to work inside you.

The ideal Stalinist style was relentlessly didactic. This was the only unambiguous interpretation of the ideal of clarity. All art that did not refer to the only possible message was considered meaningless.

In the post-Stalinist era the demand for clarity has

weakened, not as a result of "concessions" but because the message has changed. With the process of decentralization came the state's realization that it really *is* within us. Artists are now *unable* to convey any other message than that of assimilation.

If there was any pressure for this change on the part of artists, it was not because of a demand for antisocialist or apolitical art. We began to resent the Stalinist version of the principle of clarity because it showed a "lack of trust." Where dogma is thought to be necessary, our own inner sense of order is not fully trusted. We sought the approval of various styles of art *in order that* the state's message be credible. Our function—and art's function—remained the same. Style serves function. Content is made more credible. Pluralism of form helps to unify society.

Today we must create art that is living proof of the state's integration with society. The common good is not merely an external demand but is life itself. Artistic creation is the living paradigm of socially useful activity rather than its guide. We need no longer be overtly "political" in order to be considered unambiguous. We merely have to point out the roads to Rome rather than preach Rome itself.

Thus, the principle of clarity has metamorphosed into that of interpretation. The work of art *must* admit of an officially acceptable interpretation, and nothing must exclude *this* interpretation. We now have the right to use irony, provided that it is affectionate and understanding. Our work is even allowed to be fantastic, provided that we remain within the gravitational pull of socialist reality and equip ourselves with the ideological parachutes necessary for a smooth landing in the unlikely event of

a crash. We may build labyrinths, but only if there are road signs on their walls. Our heroes can be introverted, but we must have the key with which to open them up. Who would have dreamed of such freedom in 1956?

The principle of clarity today differentiates between the various social strata. We had to be artists for *all* the people at the time when only one make of winter coat was available. Today's state artist may now choose to fulfill the aesthetic needs of one employee group only. In the past the least sensitive group provided the standard of clarity; today this is not so. Today the work of art might be intelligible only to the most attentive audience: the state's experts.

The principle of clarity has lost its literal meaning for good. It has become a game played by the cognoscenti. The bulk of the mass audience can rest assured that the show satisfied the supervisors of clarity, even if they themselves did not understand a word of it. Otherwise it would never have been shown to any audience, however small. Today, our work may be unreadable but never misread.

The Power of Context

So I do not have to glorify Party and state, the soul and body of the common good. I need not even celebrate the corporate society as the triumph of intellect and sentiment. It is sufficient that I do not reject the idea of the planned common good and do not preclude the possibil-

ity that the planners of the common good might ultimately succeed. I may express my discontent, even my unhappiness, as long as I do so constructively. I may utilize any possible means to achieve the publication of my works, the exhibition of my paintings, and the showing of my films.

But if the expression of my artistic consciousness is made public, this will have happened only because I have employed a coauthor: the state. My audience knows that I am a permitted author with a permitted message. The expression of my aesthetic sensibility can be neither imagined nor acted out in any other way. I am the painter, sculptor, signwriter, chronicler of the pharaoh: even my most personal discovery or insight is used only to decorate the pyramid of socialism. All my creations are based upon a set of axioms; my aesthetic explorations are variations of acknowledged truths.

It is vanity of vanities to believe that artists and audience are smarter than the state's administrators, as victims of old-fashioned censorship might have hoped. We contribute to the co-optation of our audience with our art and, for its part, the co-opted public's ears, eyes, and taste buds further co-opt our art. Nationalized consciousness speaks to nationalized consciousness. Even the unhappy consciousness is nationalized, as is the lonely one. It was not a mistake but a masterstroke on the part of censorship to have passed the artist on to the audience. The social context swallows up even those techniques that the artist might have hoped to use for alienating effect. Traditional censorship might have provoked resistance, but the repressive tolerance of the new aesthetics of censorship has created aesthetic automatons.

IO

THE TRUTH ABOUT
SOCIALIST REALISM

THE STATE is the proprietor: it maintains and manages art. The state is doctrinaire: it chooses its aesthetics. All attempts to separate these Siamese twins are bound to fail. Some have tried, of course. In the Soviet Union the twins are called "writers' association" and "socialist realism." Revolution gave birth to them after ten years of blood and pain. The resistance of those who did not want doctrines was gradually weakened. Authoritarians expelled anarchists, their former comrades in anticapitalist negation.

In countries like China and Cuba, where genuine revolutions also led to socialism, similar protracted cultural battles proved that the romantic anticapitalist is not the agent of the future. The anti-authoritarian rebel wanted to salvage freedom and individualism, those unfulfilled promises of the bourgeoisie, from the wreckage of capitalism. Once in power, he wanted to enjoy the privileges of socialism while behaving as though he were intellectually independent. But he was quickly reminded: "Within

the Revolution, complete freedom; against the Revolution, none." He liquidated himself.

In countries where socialism was imported, cultural experts primed for social unification were waiting in the wings for the planned society to come about. These countries were also fertile ground for socialism. But they lacked the ferment provided by the anarchist vision that perhaps was needed for an independent revolution to occur. Directed culture is rich in national variations, but it is securely maintained everywhere by the state monopoly on art and the official aesthetic. No Solomon has yet proved capable of sundering these Siamese twins.

Why "Realism"? Why "Socialist"?

It seems that nothing is more alien to directed art than the relentless exploration of reality. Realism, it is said, cannot exist side by side with taboos, yet socialist art is surrounded by them. The slogan of realism seems to be the most unsuitable of all possible aesthetic principles. But there is, in fact, only one taboo: the recognition of a *variety* of realities is forbidden, including any separate reality of one's own. "Realism" operates this way not because it does not wish to know about reality. You do not need much theoretical training to realize that there can be no "real" reality where there are many realities. The aesthetics of "realism" require only a little effort:

recognize that *reality* exists! Just a little *realpolitik* and our dreams will be more peaceful!

By the same token, the adjective "socialist" is neither some cunning exemption from faithfulness to reality nor a restriction of "objective" reality. It is not even there to enforce the propagation of a dogma, party, or government. The adjective is merely a reminder of the artist's reality. It simply means: *realism here and now.* What I have to be faithful to here is the reality of socialism. This is often and misleadingly formulated as a demand when it is, in fact, a description of a condition. The reality of my employment and expertise are defined here: this is directed reality.

The printer who prints my books, for example, is a part of this controlled reality. He has only two choices. He either creates a book that can be passed on to the other departments of his firm or he does not print the book. My text includes him and with each word repeatedly incorporates him into a reality that is inescapably *our* reality.

My sentences are a part of respectable reality for him, because they are a part of my manuscript. Regulation, taboos even, dictate to him: for example, he is forbidden to rewrite my sentences. But note how even the taboos help him to do a faithful, precise job: to be a *realist* printer. His position itself helps to guarantee his loyalty. He too is a company artist. And his art is that of the company itself. I hope he likes his work. I hope I have not spoiled his day. Socialist realism is the aesthetics of work for the company writ large—that is to say, the state.

My feeble book, being a part of the art of society itself, will mirror reality only if it is directed. But the state no

longer has to concern itself with the details of my work, as my viewpoint is identical or at least similar to that of the management. The moment that my art faithfully mirrors reality, it becomes a part of that reality.

Change of Costumes

Medieval artists were servants: to God or to the king. In modern times, artists have had no common purpose other than exploring the aesthetics of their media, just as merchants are moved only by the metamorphoses of money. The state artist wears another costume—that of the social planner. He reduces "reality" to society, or even to the "tasks" of society. This reduction is not anti-artistic; it is simply unusually modern. This is the sensibility of the man of the future: he is the social planner. Painters, once upon a time, reduced "reality" to swatches of color in order to better "capture" its essence.

Actually, socialist realism has described quite well the new garb that we have donned in the historic changing room of the artistic personality. What does theory demand of us?

Our ethos must be "positive" as well as "active." Our work must emphasize and embody the secure consciousness of existence, the individual's organic dependence on the whole of society, and the mutual interdependence of everything that exists. We must make plain the inner harmony among different parts of the entire society. And we must never forget that the artist

is an educator who must express himself with clarity. It is our job to draw attention responsibly to general anxieties. Once again, György Aczél, with his customary exactitude, shows us the way: "It is necessary that art should show everything that is bad as well, that scandalizes us, including things which are still around us. But the picture must be chiaroscuro, a true image of reality, and it should not be servile to passing fashion!" We must shape reality, not merely capture it. As Marx put it in a famous exhortation to philosophers: the task is not just to understand the world but to change it. So too with artists. "Socialist realism" is more than mere faithfulness to reality: it contributes to reality; it creates reality. Whatever the genre in which we work, we will regard reality from the point of view of the state, which perceives people and things (and sees them as real) only from the standpoint of social integration. Again, Aczél:

The clerks [he means the intelligentsia, of course, but his term is perhaps somewhat more precise] can only be accorded a really growing part in the further democratization of our society if they do their bit to keep our country on its feet, to strengthen the sense of identity and consensus of the nation, to improve manners and educational standards by their value-creating, value-transmitting, consciousness-shaping work, and by strengthening the socialist way of life and public feeling, driving out evil, thus giving enriched meaning to the lives of people. Such responsible intellectual action derived from sizing up the situation with a sense of realism, such a creation of values, shap-

ing people and their thinking is needed more than ever.

Any artist whose perception is different is not a real artist, in the same way that painters of the previous era considered dilettante those who thought they portrayed "real" objects (whether "apples" or "morals") instead of mere forms and colors.

Our apple is *non*-apple in a different way from Cézanne's.

The School of Discipline

What passes for socialist realism in China has long been dismissed in the Soviet Union as a neophyte's excess of enthusiasm. Sophisticated Soviet critics today praise the sort of art that escaped punishment in the 1950s only because no one dared to create it. But the Soviets still see the Cuban version of socialist realism as petit bourgeois avant-garde. In Hungary and Poland, socialist realism is now mentioned only on festive occasions. Theory is cherished as sacred, preserved by a nation respectful of its traditions—even those no longer in use, like its first railway line.

We observe the backward parts of our civilization benevolently: they still adhere to the rules of a narrow notion of socialist realism. We know that initially it is necessary to make special demands on the aesthetics of

assimilation. As we have seen, military or hard aesthetics often precede a period of relaxation and reform. In the first phases of the new historical epoch, detailed, overt, and rigorous criteria for measuring the extent of assimilation make the life of both the state and the intelligentsia easier.

Classical socialist realism is a school of discipline. The new class—the dictators of the proletariat—probably sincerely envied the industrial discipline of the workers in whose name the revolution was made. (There is a proletarian interpretation of culture even in the new African socialist states where there was no working class to speak of. But the aesthetics of socialist realism are strong enough to create their own context. There are songs about discipline even before there are disciplined choirs to sing them.) Initially, the state looks for the ideal of the New Man in the image of the honest worker. Only after having finished their education in corporate discipline do the men of the Party and the state turn away from this ideal, realizing that they themselves are the ideal model.

Artists search for a permanent formula of discipline for the new class. The industrial discipline of Stalinism cannot imbue the new civilization with the maturity it needs to take root, thrive, and grow. It merely provides the transition toward embracing the ethos of the engineer, who can be trusted to execute his responsibilities as a member of the elite.

In Hungary the "hard" aesthetics that glorified the worker were already being dispensed with in the 1950s. The state came to understand what was essential: the worker only needs to get up early, work the machines,

and keep his hopes up. Everyone is then contented: the worker is happy to be left in peace, and the artist is relieved because he no longer needs to be the purveyor of aggressive propaganda.

Not that the transition was easy. The idea that the New Man was *not* the worker caught on only with difficulty. In Hungary, even artists of proletarian origins were reprimanded if they criticized the direction that progress was taking. They were slow to realize that while the workers' state may theoretically be the creation of workers, its power belongs to an educated elite. The working-class ideal—and its aesthetics—was necessary to instill industrial discipline in the factories. But socialism evolves, and we must give up the crowbar if we want to help build the radiant future. The passionate sons of the proletariat were reminded that theirs was only one of the many possible paths to the creation of the socialist state. The proletarian artist posed a double threat to the revolution that emancipated him. His stubbornness might have prompted a new class war, or a new individualism. Therefore, he was told that he must work for society as a whole, to be an artist for all the people and not just those who happened to be born with a blue collar around their necks.

Since then, Hungary has been busy exporting better-than-average products to other socialist audiences, even in the sphere of aesthetic theory. In the 1960s, a hitherto rejected version of socialist realism became officially acceptable. Georg Lukács suggested that the principle of realism ought to be interpreted not as a mass of prescriptions but as a framework for a kind of freedom that can be reconciled with reality. This theory asks only for the

assimilation of the artist. It was Lukács himself who proved the pacifying loyalty of his theory when he became the leader of artists' protests, at the time of the economic reforms, against the commercialization of culture. By the time his pliant theory became state practice, it had taken on a shape suitable for official consumption. Here is one official Hungarian definition, according to Ivan Vitanyi, director of the People's Institute of Education: "Realism is the kind of portrayal of the social state and social space that corresponds to reality and to the possibilities hidden in reality." Aesthetics that are less political than this are impossible in state socialism.

II

THE STATE ARTIST

"THE WRITER is the engineer of the soul." This dictum of Stalin's is more to the point than any of his followers' lengthy paraphrases of it. It encourages us to tinker with the consciousness of the public. This metaphor is also an ingenious definition of the scope of artistic freedom under the conditions of totalitarian socialism: we are neither more independent nor more defenseless than the engineer. The state artist, too, is an organized professional.

This metaphor also implies that censorship and self-censorship are essential, in the same way that the engineer must reject his own exciting, but solipsistic ideas. His job is to make certain that trains run smoothly and on time, not to determine destinations. Stalin's apt dictum signals the historic demise of the "independent" intellectual. Henceforth, social planning embraces all previously independent activity.

Where the individual's and the artist's short-lived autonomy are replaced by an assimilation similar to that of Egyptian, Chinese, or medieval cultures, one is too easily

tempted to blame this on cultural backwardness. But Stalin's metaphor is not an abuse of industrial society's ideals. On the contrary, it is the metaphor of mature industrial consciousness. Those who do not insist on the dogma according to which freedom and progress are interdependent will recognize that the Marxist-Leninist project can be furnished with the achievements of post-industrial society.

Stalin's metaphor would be acceptable to any capitalist television company. Totalitarian socialism simply removed the obstacles that stood in the artist-engineer's way. It stimulated the hegemony of expertise through violence. Our new civilization may have experienced particularly sharp labor pains, but it gave birth to an industrial discipline that surely must be the envy of those capitalists in the West who still have to contend with unruly unions and surly workers. The socialist state's identification of art with education is the open tyranny of the modern age. Planning allowed a glimpse of its nature as openly as this only in societies where it encountered little democratic resistance.

It might seem as if extreme poverty contributed to the need for centralized planning. But economic "backwardness" is simply a good precursor for nationalization, a kind of baby food. When the culture of socialist planning has matured, it realizes that it came into this world to be society's ruler, progress's God, in a civilization created for its sake.

Stalin's metaphor envisages a society in which his followers can afford to experiment with variety and depoliticization. But the state artist remains the engineer of the soul even in a "decentralized" society. We no longer

wish to cut the umbilical cord that connects us with the whole of society, because our soul is like that of an engineer.

How Does One Become an Artist?

One becomes an artist the same way one becomes an engineer, scientist, policeman, army officer, journalist, economist, manager, politician, lawyer. You simply obtain your degree at a university where you have learned the skills of your field—just like any other aspiring professional.

Naturally, there have always been art colleges, some distinguished, recommended to young artists who wished to start their careers knowing the tradition while gaining abundant technical experience with the help of good teachers. State socialism could not, of course, let such institutions continue without some guidance. Art education, too, had to be liberated from its lack of historical responsibility, from its propagation of all varieties of aesthetics. Its students, after all, were at the mercy of every passing trend. Moreover, they lived in shameful poverty. The state, in its wisdom, would fix all that.

Following nationalization, mergers, and the founding of new schools, a unified system of art education came into being in every socialist country. Now each art form has its own college, and its diploma is the equivalent of a university degree. Each college trains its students in many different specialties, and these correspond to genres or techniques (for example, painting, sculpture,

or graphic design in the School of Visual Arts; directing, scriptwriting, or cinematography in the Academy of Film).

These art institutions have a monopoly on their field. Their principals and professors are appointed by the state, and students have no say in the matter. The Ministry of Culture coordinates their curricula with other colleges and with the national system of education. The same compulsory *Weltanschauung* subjects are taught, such as Marxist philosophy and history. Art and literary history syllabi are drawn up by the relevant university departments. The curriculum has a clear direction; it is compulsory, and semesters finish with strict exams.

At graduation, students receive a diploma, which is also a license to practice. Without this diploma one may only rarely be admitted to the artistic community. The only exception is in literature, whose educational system has not been formalized in some socialist countries.

The emancipation of education in the arts is made complete by the fact that the only existing route to an art career is also free of charge. These colleges are considered to be for an elite, and ambitious parents seek to place their precocious offspring in these prestigious schools.

I do not wish to waste too much energy describing the educational process; suffice it to say here that almost as many people graduate as matriculate. But the reader is right to suspect that spontaneity and independence are encouraged only when they are consistent with the artist's new role in shoring up and deepening social integration. Free education, a diploma that guarantees commissioned work, professional status: these are all advantages

that would make no sense if they could actually be used. This careful education provides the kind of knowledge that is useful only within its own artistic community.

After a promising start, the educational system gives up any attempt to instill a special sense of passion in the would-be state artist. These artists are educated to be unable to create anything unpublishable. They are trained to be creative executors. The aim is to make artists maintain the state institutions of art. State art education trains state artists.

The Numerus Clausus

During the interwar period, laws were passed that limited the number of Jews permitted to enter Hungary's institutions of higher education. Those laws were called the Numerus Clausus. Today socialism uses a similar device to place a limit on the number of people who may become artists. Restricting their number is probably even more important to securing the future than is the actual content of curricula. The system of limited enrollment kills two birds with one stone. The required ethos of "proper attitude" is achieved without much need for disciplinary action. At the same time it is possible in this way to plan the size and proportions of the artistic community.

No intellectual profession in state socialism is exempt from the Numerus Clausus. If quotas prove too inflexible, this can be remedied simply by revising allocations,

which are decided by committees of experts and are an expression of political consensus—and of financial considerations.

The unshakable rule of state planning depends on firm decisions to redirect applicants from the popular to the less popular (but equally necessary) professions. The limited number of professions is centrally determined. Competition is fierce, especially as applicants are mindful that the state makes employment compulsory for everyone. No one shall be denied work, even if the work awarded is not one's first choice.

It would be wrong to think that the Numerus Clausus adversely affects professionals. It is in their interest that there be no unemployed intellectuals in any field. The reasons are twofold: On the one hand, the existence of an educational surplus would cast doubts on the graduates' natural role as representatives of the people, undermine their privileges as leaders, educators, and planners, and, even more dangerously, gut the proposition that the state and the common good are identical. On the other hand, such an uncontained surplus would be adventitious, its expertise aimless, its actions irresponsible. Its very existence might suggest the possible alternative of an independent intelligentsia. It is incomparably more advantageous for the organized intelligentsia to constitute itself as a closed shop, with a regulated membership.

The Numerus Clausus ensures that each group of intellectuals can remain a part of state administration, where it can work for mutual advantage, making sure its needs coincide with those of the entire society. The Numerus Clausus strengthens the prestige of the new civilization's guardians of consensus. At the same time,

the continuing regulation of enrollment guarantees that graduates can look forward to a safe future. The student who wishes to become an educator himself will want to be certain of this.

Talent

The allocation of student numbers is independent of any discriminating notion of "talent." On the contrary, the definition of a talented person is that he was one of the few admitted in a given year. More important than sheer talent is the candidate artist's suitability for education. He must not show too much originality, quirkiness, or spunk. His knowledge must conform to official culture. Politically, he must be neutral, at least, if not an enthusiast; but he must not be naïve and, of course, not alienated. He is admitted to the competitive examination that selects the predetermined number of students only if he shows these characteristics. Even at school, "talent" does not mean simply creativity; it includes an individual's receptivity to directed culture.

In the tough competition for places, those people will lose out whose only claim to be artists is their talent and who show too blatantly that they are prepared to learn anything but their task. In the eyes of the state, failing their degree exam strips them of their claim. There is no official differentiation between the rebellious and the truly untalented, nor could there be. Their desire to create art is purely subjective in the eyes of the state.

In the event, none of this is much of a headache. There are just not many troublesome applicants. The raw material coming out of the country's secondary schools is already culturally homogeneous. Most students can't wait to become licensed state artists. All that remains is to choose the best of them.

The limitation of numbers, with its power to define talent, helps to create the elite consciousness that forms the basis of further education. The greater the surplus, the greater the prestige of those lucky few who have been accepted.

Students themselves consider the policy of limited enrollment fair. They justify it by citing the necessity to select for talent. This policy thus is an inherent safeguard against student protests. By the time we graduate, we have learned that the Numerus Clausus works to our advantage. It is true that initially we are motivated mainly by fear of disqualification, or of disappointing our parents and ourselves; and so we avoid conflicts, apply what we have learned *in the correct way*, innovate in ways appropriate to our student status, and cultivate personal relationships with the institutions of control.

By the time we graduate, this discipline will have made sense. Our art is imbued with the ethos of leading experts, who express their free will in their voluntary cooperation with the state, according to its rules, of course.

I know that in democratic societies some professional bodies also regulate the education of their membership and limit the number of graduates with the help of the state and, as a professional body, permit only its loyal members to practice. In applying Numerus Clausus,

medical doctors also refer to responsibility, but it is, in fact, employed more in the interests of maximizing the professional body's prestige and income. Doctors can protect their corporate interests in democracies. But artists, it seems, need the *diktat* of the state; we need to be rid of democracy if we are to have such protection.

Professionalism and Liberalization

Art can be taught in schools only if professional judgment and political loyalty are not separated. From the point of view of the future of state culture, there is nothing more desirable than having professional artists who do not differentiate between what they learn in the interest of their art and what is in the interest of their social position, between their private dreams and their public obligations.

This strategy has been so successful that the state has dropped numerous regulations as no longer necessary. Besides, it is easier (and more effective) to act as the judge of quality, dispensing permits according to the suggestions of artists themselves. Artists' own sense of professionalism has become one of the strongest links binding the artist to the state.

In the post-Stalinist period, assimilated artists are quick to react against any morality that is not that of the assimilated professional; it is the defense of a guild toward all outsiders. Open resistance to the state is seen as professional cowardice. We protest against it not in com-

pliance with official orders but with inner conviction, in self-defense.

"Everything can be expressed, but you need to know how," say the professional artists and professional controllers. That which cannot be presented as constructive social criticism and respectful innovation is not art. But "not art" no longer means that it is "hostile subversion." Well-meaning political mistakes are seen as mere professional immaturity. As our beloved Aczél recently said:

> We do not ask artists of differing opinions and ideologies to give up their convictions and to join us uncritically. . . . Nor is there any intention to prescribe ways of holding hands, how one should furnish one's home, how one should feel, what one should be happy or sad about. . . . An honest citizen of Hungary is worthy of respect even if he is one of those said to "think differently." . . . [But] authentic artistic fulfillment can only be embodied in meaningful and valuable art.

The liberalization that followed the upheaval of the mid-1950s saw the creation of three distinct categories: *prohibited*, *tolerated*, and *supported* art. These are not political categories any more than are the categories of *unmarketable*, *nonprofitable*, and *blockbuster* under capitalism. These are simply categories of quality and success. In some cases these categories might be unjust. But, as professionals, artists cannot afford to hide their failures behind their discontent. With a few exceptions, those who complain about oppression or censorship are just being lazy. Hard work and real talent—not com-

plaints—are what will move our works of art from being prohibited to being tolerated, and from there to being supported.

The Amateurs

We do not ignore amateurs either. It would be difficult to maintain the concept of art's popular educational role if the professional level necessary for a university degree were allowed to loom so large as to form a major obstacle to those interested in dabbling in art. There are extensive regulations to take care of those who would make of art an active hobby.

Naturally, only those with an amateur's license can be amateurs. A central office issues these, then arranges performances or shows, and regulates permissible income. Private performances are banned, whether indoors or out in the streets. One may accept invitations only from authorized institutions. Independent amateur activity is not allowed. Individual genres are organized into artistic workshops. These—for instance, amateur workshops in the fine arts—work on the premises, and under the supervision, of the local administrative centers.

These workshops are the "guardians of local culture." Therefore, they are forbidden to have political interests. That is the privilege of the professionals. Amateurs do not have to aim at "total social validity." It is best if they

are apolitical (as in the case of a magician, for example) or unselfconscious (as with, for example, a charcoal drawing of a nude).

In some arts it is the task of professional artistic workshops to supervise amateurs. Writers, for instance, may publish their articles in periodicals but will remain amateurs until their first book is published. Without any such welcome event, they will still be considered "young" writers, often after ten or even twenty years of published work, because this is the term used to describe amateurs in those arts where a diploma is not a requirement.

In some areas—periodicals, film studios, for example—special workshops are established for "young" artists. These are peculiar phenomena. Because of the "age-specific characteristics," which are treated by official aesthetics as a kind of illness, these work like therapeutic institutions. Somewhat more irresponsible work is permitted in them, but only because they have a limited distribution. Only patients restored to full health may enter the "adult" workshops.

It is perhaps worth mentioning that there are two types of professional artists. Those who earn their living entirely from their art are quite separate from those who, while possessing professional licenses, also have a job. But this latter group must not be confused with the amateurs. They are different not just because of their professional license. Professional artists of all stripes are employed almost entirely in the factories of culture, whereas amateurs must spend their working hours building socialism outside the institutions of culture.

One of the most common occupations for professional

artists is to be the manager of an amateur or "young" artistic workshop. The responsibility of being in charge matures the artist while also preparing him for a role as the leader of a professional workshop.

Amateurism is often run like a movement—most often the so-called competitive movement. This is the most successful method of neutralizing spontaneity of expression. Competitive movements mount annual "demonstrations," with honorary or material prizes. The highest prize is the publicity afforded by an appearance on television. In some amateur festivals the most distinguished professional artists award the prizes. When the amateur winners return to their everyday lives, they are toasted by the local authorities, their neighbors, and their fellow workers. Some are "discovered"—and then sent to college to become real state artists.

12

THE SPACE BETWEEN
THE LINES

IN THE MODERN socialist state a professionalist ethos replaces ideological adherence. But this development does not bring ideological freedom. The myth of a unified society is still "valid." It is respected as much as are the cohesive norms in any traditional society or institution. How does this myth remain so powerful?

In art colleges the compulsory *Weltanschauung* subjects gradually become a system of widely shared symbols. The "study" of Marxism is merely the ceremony of initiation into the tradition of social unity. However contemptuously, we nonetheless patiently observe the initiation rituals. The state religion bequeathed to us by our Founding Fathers remains indispensable; it is the system of signs that enables professionals to recognize one another.

Our ideological conformism does not, of course, prevent us from smiling when encountering the dogma. Often, bureaucrats and artists laugh together. Enlightened as we are, we consider the liturgy to be a sign of

narrow-mindedness—an idolatry, a childish extremism when compared with our own natural, simple discipline imbibed since infancy.

But our cynicism is a conceit that has no effect on our behavior. Marxism is still the foundation-myth of our notion of civic responsibility. It is the legend that legitimates our ideas of service to the people. It is a comfortable euphemism, like the ever-popular story of the stork told to children.

Official ideology is the outward trapping of our message, not its inner life. At least this is so in those countries where directed culture has embraced civilian or "soft" aesthetics.

We act as though we only illustrate official ideology; in reality, we replenish it. János Kádár has said that in the one-party state care must be taken to ensure that the party is also able to be its own opposition. We are that opposition. Sometimes we encourage certain tendencies within public opinion; at other times we seek to counter them. Often, in this way, "meanings" are created that point beyond the consensus of the moment. And not infrequently our views can be read "between the lines." Such views might even become part of the common good: they may gain recognition in official newspapers, decrees, and textbooks.

Observers might well imagine that here is the long-awaited proof that art is an adversary of the establishment, even in its period of abject servility. What else would one find between the lines other than restrained protests, signs of cautious independence? The fact that one can read protest between the lines is, it is said, a

concession of censorship that will all but defeat it. Directed art was effective only as long as it was able to force art to remain a mere echo of ideology. In this view, state culture's decay becomes unstoppable the moment that art achieves the freedom of diverse interpretation—even if only between the lines. Cultures that speak in forked tongues cannot long endure. Aware of the failure of classical censorship, these observers regard expressions of autonomy, however feeble, as cause for optimism.

Civilization Between the Lines

But I think that perhaps memory is short. Sinologists particularly relish the discovery of irony, satire, and irreverence in the poetry of millennia of empire which had seemed initially to have nothing but praise for the emperor. In the Middle Ages, too, did not heretics reinterpret accepted dogmas, and were they not condemned, until their views were later accepted? Surely I have no reason to consider totalitarian socialism's double talk any more destructive or short-lived than that of its predecessors.

Communication between the lines already dominates our directed culture. This technique is not the speciality of the artist only. Bureaucrats, too, speak between the lines: they, too, apply self-censorship. Even the most loyal subject must wear bifocals to read between the lines: this is in fact the only way to decipher the real structure of our culture. Real communication takes place

only between the lines. And it is public life itself that is the space between the lines.

The reader must not think that we detest the perversity of this hidden public life and that we participate in it because we are forced to. On the contrary, the technique of writing between the lines is, for us, identical with artistic technique. It is a part of our skill and a test of our professionalism. Even the prestige accorded to us by officialdom is partly predicated on our talent for talking between the lines. What is unsaid is at least as important as (and often more important than) what is said.

This game is not, of course, an opening for independent trends, or for independent people who think they have bought themselves freedom of speech by making false declarations of loyalty. The space between the lines is proportionate to the widening of the state's social base. Our messages between the lines are suggestions sent to the same state and the same public that our official lines continue to serve. Debates between the lines are an acceptable launching ground for trial balloons, a laboratory of consensus, a chamber for the expression of manageable new interests, an archive of weather reports. The opinions expressed there are not alien to the state but are perhaps simply premature. This is the true function of this space: it is the repository of loyal digressions that, for one reason or another, cannot now be openly expressed.

While we are permitted to be spokesmen for certain tendencies, we must not organize ourselves into parties—even between the lines. The various creative workshops—editorial boards, publishers, film studios—must not betray any particular bias. They have to present to

the state an assembly of works that exhibits "balance." Or as they say in Hungary, one that "engages on many fronts." They themselves have to act as the state in microcosm. Here one can see even more clearly who is the real audience for these messages between the lines: not society but the unifying state. Our special interests could not be freely expressed even between the lines if they were to suggest that the state's coordinating role is either unnecessary or impossible. On this point, György Aczél is quite firm: "The formulation of the rules of the game, of the essential conditions, and legal supervisory powers (use of the veto in certain matters) naturally continue to be within the competence of the socialist state."

Let there be no mistake: art between the lines is not revolutionary. It opens no new dimensions in our closed world. Those of our special interests that are tucked away there lack the very pressure that could push them into the open, namely, the will to independence. For the expression of such a will is excluded, as a matter of course, even from this more permissive space. Moreover, this impulse can be recognized as a desire to escape this space; independence has more of a chance of survival outside directed culture than within it. Any opinion published for a directed audience is, by definition, unsuitable as a negation of our civilization's presiding spirit.

Naturally, artists do not merely work with ideas. We are also expected to demonstrate sensitivity and subtlety of form, and so it is easier for us (as it is not for others) to express criticism or sympathy. Thus, we may express our views on public affairs by way of anachronism, or by mixing the portentous with the commonplace, or by

reinterpreting a genre's conventions, or by exaggeration, or by derision of bygone heroes, or by an unexpected elision of well-known expressions, or through discontinuities or cadences of meaning. Experts in subjectivity that we are, we may be bolder with our prophecy, more sentimental in our reasoning, or more subjective in our judgments than other advisers can be.

But even we can only be the state's conscience at best. So even when we are critical between the lines we never try to hide there anything we would express had it been allowed. Actually, we have no idea what our message would be if it could be freely articulated.

The space between the lines offers relative freedom without risk, and so we may profess ourselves to be the lobbyists of innovation. This well suits the state. Our art has become a subtle barometer of all the tensions that could threaten to shatter state culture. This phenomenon has no dynamic and no direction of its own. It is the froth churned up by the perpetual waves of decentralization and recentralization. If state artists fight for anything between the lines, it is solely for the survival of this space.

Superior Solipsism and Pacified Pluralism

As a state artist, I give expression to permitted beliefs. I am also free to anticipate sentiments that will one day be accepted. I argue about public abuses. I serve and teach. But all this is just a part of my constant effort to perfect

the form of state art. My art elaborates on the autonomy and solipsism of the whole of society because the individual's autonomy and solipsism are now extinct. My fondest hope is that my work might become a classic of the new, superior solipsism of socialism. This hope will be realized if I can express my commitment to the state even in the most personal aspects of my polemical art.

"Represent, fight, suffer, triumph!" declares the poet, often not stopping short of a parliamentary seat. The trajectory of our careers is accompanied by heated debates. Youngsters witness our battles when they first learn about culture. They understand that it is we who keep inventing and shaping traditions, modernisms, aesthetic conflicts, and values. One-dimensional adventurers that we are, we become the functionaries of our own inventions. But however big the stakes, our "struggles" do not get out of hand. Surprising as it may seem, we are more tolerant than our predecessors under pluralist democracy, who perhaps did not even realize that they were pluralists, since they were too preoccupied with fighting each other.

Everything that exists will peacefully coexist: classical and modern, teacher and pupil, popular and serious. As one Party official rather succinctly said: "Socialism does not involve a world without contradictions and conflicts, but it is a society of resolvable, reasonably reconcilable contradictions." Our license to practice our art guarantees us a certain existential space, and our debates will neither broaden nor restrict this space significantly. For we do not need the public's favors—these might even compromise us. On the other hand, the favors of the real audience—the state—will be dis-

tributed equally among all those whose works are on the list of accepted diversions.

No one should therefore mourn the passing of old-fashioned competitive pluralism. The virtue made out of necessity is now replaced by a pacified, superior pluralism: the fruit of committed art.

13
THE DIALECTICS
OF DISSENT

IN OUR CIVILIZATION there are only two kinds of dissidents: Naïve Heroes and Maverick Artists. Both are doomed to irrelevance.

The state artist recognizes that the only freedom within the socialist system is that of participation. He understands the impossibility of creating art that transcends the system which permits it to exist. He knows the futility of seeking to smuggle messages of freedom between the lines. He could, of course, cling with cunning, heroic naïveté to this illusion. He could proceed as though censorship were not a law of existence but merely a kind of corruption, a necessary evil, to be endured, or to be circumvented. In other words, he could try to demonstrate his "freedom." That is what this writer does, for lack of anything better.

But this strategy is seriously flawed. It isn't just that such "freedom" is forbidden: it doesn't even exist. It is not, like murder, an act that can be committed. The greatest problem with this freedom is that its existence cannot be demonstrated.

Our hero's naïveté is not that he believes there is no censorship but that he thinks there *is* and that it is intended to muzzle *him*. What he fails to understand is that by rejecting self-censorship it is he who has transformed freedom within the state's monopoly into a straitjacket.

Our censors are interested only in artists who consider them colleagues. These artists can even create bad art, go astray, or be ignorant. As long as they remember that they are employees, they can count on the privilege of being censored. Legitimacy will then be theirs to enjoy. Their aesthetic experiments will have a chance to turn into social possibilities. Their nihilism will be neutralized. Their work will be "refined" from cruelty into compassion, from tragedy into lyricism, from absurdity into farce. Such work is then made available to a selected audience in the right place and of the right size, and finally, with the help of critics, instructions for use are enclosed with the product.

This happy fate is denied to the Naïve Hero. Artists who refuse self-censorship are rejected by the censors: they are exiled from the world of aesthetics. Their work cannot be produced, published, or displayed—not, at any rate, as art. The artist's professional license is withdrawn; his privileges are revoked; he is ostracized by the artistic community.

Please understand: the artist excludes himself not necessarily by what he "says." That might simply have kept our controllers busy. After all, a lot can be squeezed in between the lines!

The rejection of self-censorship is so rare—and so radically different from its acceptance—that all right-minded employees prick up their ears when they hear

of it. The driven dissident will come to be discounted by the state as a political protester. His art will be branded a mere vehicle for his political discontent. In this way he can be taken to task. He will soon find himself in court, where the prosecution will seize upon particular aspects of his creative work. The artist will appeal, in vain, to the organic nature of art. But he is no longer an artist. He himself has renounced his position as a professional expert by refusing to cooperate with the institutions of the state. He is just an ordinary man in trouble with the law. Once in court, all citizens are equal. Art that is unauthorized is always potentially subversive.

From being a member of the elite world of aesthetics, he has now become one of the masses. He can claim no special privileges or rights. If he does so, he really *is* naïve: he is an accomplice with his accusers in an alliance that is useless to him. For the Naïve Hero the future holds nothing but endless conflict. Now he realizes that he was free and that he has wasted his freedom.

Thus the naïve assumption that a state employee can simply pretend not to know his employer leads to an impasse. And so some try to make direct contact with the public by circumventing the state. This writer too has tried this—to no avail.

The Maverick Artist's "freedom," too, exists only in theory. Whereas with the Naïve Hero there is a chance that he may be excluded only from the realm of aesthetics, the Maverick Artist is considered an enemy from the outset, for he rejects state culture at its foundations. He disrupts the smooth operation of the machinery of monopoly and provokes independent activity.

The Naïve Hero challenges the state even though he has striven to maintain links with it. But he has made the mistake of regarding the creative workshops as neutral wholesale merchants and himself as producer. He has imitated the behavior of artists in a less-than-perfect market economy.

The Maverick Artist goes further and exposes the dangers inherent in the Naïve Hero's illusions. For instance, when he distributes his rejected book in typescript, he is attempting to achieve a businessman's independence, even if only in an amateur fashion. He bores through the cellular walls of the organic body of society, searching for an inorganic space within it.

The piece of art may be innocent, the audience uncomprehending. But the maverick publisher, exhibitor, or dramatist is to be persecuted, even when he employs self-censorship or his work is hopelessly derivative. For the Maverick Artist is an economic criminal.

By "economic crime" one does not mean that anybody would believe that the artist who bypasses censorship is guilty of illegal profiteering. Quite the contrary: the Maverick Artist transgresses by willingly sacrificing the privileges of the assimilated. He aims to be a poor artist in order to remain a free one.

But his cunning is transparent to those whose lifelong roles he derides. As long as the economic order is stable, he might be able to count on some followers, but not on the public's solidarity to any great extent.

First-Century Romantics

Among themselves, dissidents are often quite divided politically, but psychologically they are much the same. State culture might call them its romantic individualists. Like the nineteenth-century Romantics, who, rebelling against a vulgar bourgeois mentality, took refuge in the gallant and saintly gestures of a bygone age, so these few alienated artists of socialism seek to revive respect for the free individual. Like the Romantics, they are not heralds of a renaissance. They suffer from the fact that the transformation that has taken place in the new civilization is now irreversible.

Once they have broken with directed culture, their imagination is flooded with romantic utopias. They are obsessed with the former independence of the individual and want to plunge society back into the fecund chaos of unfettered personal passions; they wish to split apart the interlocking domains of economy, culture, and political power. Their culture is not bourgeois, and yet they are derided by the state as "bourgeois intellectuals" because of their (imaginary) independence. They trumpet the vanished pathos of individual initiative as if we were at the beginning of an era, not at its final outcome—that is, in a society of state monopoly.

But it is plain as day that their utopian longings are a product of their fevered exasperation rather than a sign of impending victory. The anachronism of their pathetic position is revealed by the amateur methods they are

forced to employ. They are least likely to crop up in those modern art forms which rely heavily on expensive technology and which use artists in collective teams. Thus, dissidents of any stripe are scarce in television, film, and architecture.

Dissident art is a romantic school inspired by its own marginal position. Only after its own death can such art enter state culture, through a process of deliberate digestion.

What Are Dissidents Good For?

It seems, then, that there is no place for such people within the cocoon of state culture. But perhaps their presence, however precarious, is part of a well-designed strategy. Perhaps they "represent" the true aspirations of directed artists like ourselves. One day, their independent spirit might become fashionable.

I hope that they are not so naïve as to believe this. I trust that in their misfortune they do not console themselves with such hopeful conceits. I hope they will derive some aesthetic satisfaction from their own eccentric marginality and will not hope for a role as harbingers.

But I fear that from the outset they have been too deeply imbued with the tradition of commitment to be able to renounce easily socialist aesthetics' most fundamental axiom: the idea of *art as service*. This writer understands only too well how difficult it is to be satisfied

simply with exploring one's own sensibility. They will want their art to play an active social role one day in shaping the consciousness of the culture of the nation.

If this is what they desire, they can rest assured: in spite of their current isolation and pitifully small numbers, they have already—and in a profound sense—become a part of our state culture. And indeed, one day things might take such a turn that they become necessary to the culture that today excludes them.

In the first place, they are products, catalysts, and victims of "progressive censorship." Their scandalous heresies served as a sign to the state that the time had come for reforms and decentralization. This was not a victory for the dissidents. The state was shrewd enough to protect its reforms from those who had provoked them. In the East, reform from above can become as much a stabilizing ideology as in the West, and its consequences can be just as disastrous for radicals from below.

According to one Hungarian saying, if Solzhenitsyn had lived in Hungary, he would have been appointed president of the Writers' Union ... given time. And then no one would have written *The Gulag Archipelago*; and if someone had, Solzhenitsyn would have voted for his expulsion.

This is the climate of opinion in the culture of "progressive censorship." We consider as unacceptable extremes both the state that is unable to reform and the artist who is unable to conform. Solzhenitsyn went too far. His novels would have been passed sooner or later, but with *The Gulag Archipelago* he proved that he was not interested in influencing policy but only in destroying the state.

Our strategy is to keep within state culture, to write along rather than between safe lines. The state is more our partner than its opponents are.

Although the dissidents have inadvertently hastened the creation of a new social consensus, they can hardly expect gratitude from the state. The fact that they are allowed to survive is something new, however. Whereas the West accepts them as part of its own culture and supports them, the East treats them as prisoners of war . . . while peace negotiations carry on.

Even in their tolerated, threatened ghetto, the dissidents serve a purpose: they are a cautionary tale. They "teach by example," as Mao would put it. Who are these people who believe history can be reversed? They are incomprehensible strangers. They are living memorials to the sad fate of individualism for a new generation that does not know the misery from which our state culture emerged.

If, sometimes, unruly artists are forced into the dissident ghetto, this is not intended to retard the development of state culture. Occasional exclusions are simply a means of signaling its limits. The trials of dissidents serve as a blessing to those artists who have remained loyal to the state. The occasional stigmatizing of dissidents guarantees a sense of security to state artists by circumscribing the permissible. Unlike the Stalinist Stone Age, sophisticated directed culture perhaps even needs an infrequent outcrop of dissidents.

Perhaps it would be an exaggeration to suggest that dissidents have become a useful category within directed culture much as have earlier accepted tendencies such as the rural Populists, who are devoted to national values;

or the cosmopolitan Urbanists, who are more open to international trends. After all, if dissidents have a place at all, that place is outside official culture, even if they are not in prison. But in their isolation they have become predictable, and their numbers can be planned for systematically. Therefore, even if they are not aware of it, from the point of view of the state, the most significant difference between the dissidents and the other tendencies has disappeared.

An era of greater generosity is about to dawn. Just as in ancient, long-enduring empires, renegade mandarins might establish Taoist monasteries. Similarly, the modern socialist state regards its die-hard dissidents as members of a monstrous, weird, misanthropic sect, disenchanted with educating the people . . . but nonetheless essentially innocent and, indeed, not without their uses.

Even their artistic work need not be wasted. The directors of tradition do, from time to time, allow a few of them into the culture. True, this is more likely to happen when they are no longer alive. Directed culture will survive, forgive, and forget their acts of disobedience.

Later, of course, some of them will be "re-discovered" and "rehabilitated." Such decisions will be reached by the central authorities. Amnesties are issued when a new ruler is installed. Almost all dissidents can count on becoming part of the official curriculum when the time has come to denounce the failures of the previous dynasty.

But even before this redemption it is apparent that dissidents have not vegetated in vain. They are nutrients, like broken blossoms in a garden. State culture can be influenced by fertile misunderstandings. We can uti-

lize their aesthetic discoveries, just as we do the experiments of Western artists. We introduce their themes between the lines. We can create "valuable" and "organic" innovations from their unacceptable conceits. Thus do dissidents become the untraceable initiators of some of our legalized fashions, the unmentionable source of some of the "problems" that are solved by "rational debate." They make cultural politicans more sensitive and critics more clever; they lubricate social integration by their brave but self-annihilating acts. The more talented and flexible the state, the more pleasurably it can suck the dissidents' vital fluids into the organism of state culture. In this way they can exert themselves to the utmost—in the cause of a progress that will be measured by their decline.

Surely they do not intend this role for their art. They should not plan a role for it! They should be selfish!

We state artists will create the altruistic art. We do not need a new task; the old one will suffice for a long time to come. We have not yet fully savored the sweetness of service to the people. We have not yet canceled the new social contract. No one can take it for granted that we shall ever be willing—or able—to do any such thing.

AFTERWORD

SEVERAL YEARS have passed since I wrote this book. It did not have any chance then—nor does it have any now—to be published officially in Hungary or in any other Communist country. But an important change has occurred in our part of the world—a world remarkable for its lack of widespread and sustained opposition. For the first time since the predictable failure of the popular upheaval in one of the provinces of the Soviet empire, there is now, in Poland, a substantial underground network of independent thinking and publishing. This is also true—to a much lesser extent—in Hungary. The temptation to take heart from this development is understandable. At least here, on the western coast of a repressive civilization that stretches from Czechoslovakia and Hungary to China and Vietnam, it seems possible for resistance to the state to be born and to survive. This is so largely because our communism is not *sui generis* communism: it was imposed upon us by an invading and then occupying foreign army. Dissent, however feeble, can at least draw upon a democratic past that is altogether absent in the Soviet Union and in China. Thus it

is possible, if you take my book literally, to conclude that I am wrong, my bleak outlook unwarranted by the defiant gestures that seem to flourish all around me. You will decline to share my obstinate pessimism, which forces me to declare that the kind of book you are reading cannot actually be written; further, that it does not even exist.

But you must also remember that for decades Hungary has been a textbook model of a pacified post-Stalinist neocolony. This fact has not been lost on Mr. Gorbachev as he attempts to wrap more velvet on the bars of his prison in order to create a less primitive and more manageable order in the heart of his empire.

I will not defend my gloomy book by telling you about the difficult times I experienced while writing it before the samizdat era. Nor will I try to prove (although it would be an all-too-easy job) how limited is the hope to be derived from the fact that this book was printed clandestinely in Hungary last year without landing me in jail. (That hope is sufficient for the printer and me not to give ourselves over completely to despair, but not nearly enough to permit us to abandon the underground in the foreseeable future.) I will not insist on pessimism at all. On the contrary, I would be thrilled if the kind of pragmatism we see developing in China would herald the inevitable approach of a true pluralism in Communist culture. But the latest turn of yin into yang—the current campaign against "bourgeois liberalization"—shows how deftly directed culture stifles the independent voices it occasionally allows us to hear.

It might well be that my most pessimistic message

is the seemingly good news of the spreading of the Hungarian model. I have called this model the "post-Stalinist" or "soft" or "civilian" version of Communist rule, in contradistinction to the "Stalinist" or "hard" or "military" style. It might well be that the spreading of this model means that directed culture has begun to decay not at all. Indeed, the Hungarian model might well represent a more rational, more normative, and more enduring version of directed culture. Mr. Gorbachev understands that in order to have a truly successful society with a modern economy he must boost the intelligentsia's sagging morale by giving it a stake in administering the future. But in Hungary we know very well the cost of such liberating collaboration.

I hope that I don't have to defend my treatment of dissent in this book. I intended the very existence of this book to be a denial of its own deliberate exaggerations. I hope that its publication is a proof that refutes the despair that darkens its sentences. For this reason I chose to speak mostly in the third person, in the voice of a state artist, rather than joining the chorus of my own natural compatriots in the ghetto of romantic individualism. Like a ventriloquist, I adopted this voice in order to deliver the verdict that directed culture confers on the independent spirit. But I hope that the sentence is rendered invalid by the very fact that it has been pronounced publicly by me, and by the fact that you, dear reader, hold this pessimistic book in your hands.

Budapest
March 1987

The Velvet Prison

Also by Miklós Haraszti

A Worker in a Worker's State